# SECRET CITY OF SOUTHEND

## Ian Yearsley

AMBERLEY

First published 2022

Amberley Publishing
The Hill, Stroud
Gloucestershire, GL5 4EP

www.amberley-books.com

Copyright © Ian Yearsley, 2022

The right of Ian Yearsley to be identified as the
Author of this work has been asserted in accordance
with the Copyrights, Designs and Patents Act 1988.

ISBN  978 1 3981 1154 7 (print)
ISBN  978 1 3981 1155 4 (ebook)

British Library Cataloguing in Publication Data.
A catalogue record for this book is available from the
British Library.

Typesetting by SJmagic DESIGN SERVICES, India.
Printed in Great Britain.

# Contents

# Introduction

The seaside resort of Southend-on-Sea is well known for being home to the world's longest pleasure pier and the Kursaal amusement park, but there is much more to the town than that. Tucked away in the maze of streets are some surprisingly secret places and curiosities, many of them hiding in plain sight. This book looks at some of these lesser-known aspects of the town.

Southend's street names, for example, provide many clues to the town's lost historic features. Why are Nobles Green Road and Eastwoodbury Lane so called? When and why did part of Leigh Road become Old Leigh Road? Why is there an Eastwood Lane South in Westcliff? The first chapter of this book explores these questions and explains why the road layout of the town is set out as it is.

The second chapter looks at historic boundaries. The modern Borough of Southend incorporates all or part of eight historic parishes. These all had boundaries dating back to Saxon times. As Southend expanded and those parishes were incorporated, their centuries-old boundaries were blurred, ignored and often lost and forgotten; if you know where to look, however, you can still find evidence of them. Additionally, whenever Southend expanded, the local authority put down markers to define its territory. Many of those markers survive, usually hiding in plain sight.

Chapter 3 looks at how the success of the town's tramways before and during the First World War led to the development of an interwar boulevard programme, using the tramway model of a dual carriageway with a shrub-planted central reservation. This programme is explored through the history of some of Southend's key thoroughfares, including the Southend Arterial Road.

Southend played a leading role in the Second World War. Many structures which were erected to defend the town still survive. A chapter on those looks at pillboxes, road barriers, searchlight emplacements and more.

In the 1960s and 1970s, central Southend was radically redeveloped, with a partially completed ring road, a new shopping centre and a 'parallel High Street'. These developments are explored in another chapter, through their impact on the townscape. Evidence is provided of how existing roads and buildings were affected.

There are several blue plaques in the town, commemorating some of its famous sons and daughters. The penultimate chapter attempts to provide a definitive list of those plaques, which commemorate such luminaries as the founder of the NSPCC, the first man to climb the Matterhorn and the first ever goal-scorer at Wembley Stadium.

The final chapter looks at a wide cross-section of unusual subjects, ranging from surviving ancient earthworks and vintage advertising to the world's first fibreglass warship and one of the world's smallest museums.

I have been researching and writing about the Southend area since the 1980s and I am delighted that the opportunity has been afforded me to write this book, as it has given me the chance to explore some of the town's lesser-known aspects and has taken me to some places I did not know much about. I hope it encourages you to explore your surroundings too and to be on the lookout for the many half-hidden and often overlooked signposts to Southend's past.

# 1. Historic Streets and Street Names

Some clues to aspects of Southend's secret past lie in its street names. To understand how the oldest of these came about, look at John Chapman and Peter André's map of Essex from 1777, which has been annotated to show the two main routes into the area from London and highlighted to show the modern names of some of the roads.

The communities at the heart of the historic parishes which pre-dated the Borough of Southend can be seen on the map, along with the embryonic road network which still forms the basis of the town's road network today. The highlighted street names are all either partially or completely within the Borough.

The importance of the two main eighteenth-century roads into south-east Essex from London (shown in purple) is underlined by the fact that they both have milestone markers on them. The one coming in from the left ends at '41M' (41 miles) from London outside Milton Hall. The one coming in from the top, via Rochford, which is off the map, ends at '44M' by Tile House. It can be seen from this that the two main historic routes in and out of the area were the roads to London and Sutton. The highlighting shows that these are unsurprisingly named London Road and Sutton Road, respectively. What this demonstrates is that the earliest road names were geographical: they were named for the places they led to.

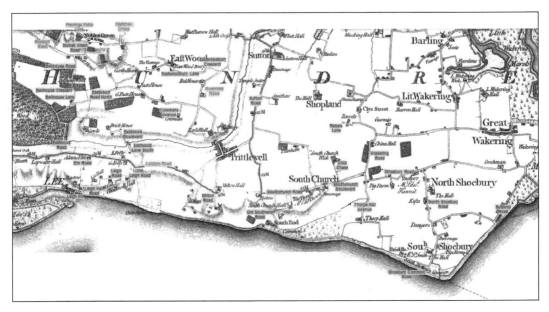

John Chapman & Peter André's map of Essex from 1777, showing the main routes into south-east Essex from London and the modern street names of some of the roads.

Sutton Road in the early twentieth century, one of the two main historic routes into the area now covered by Southend.

According to Cambridge historian David Butterfield, who wrote an article about 'British Street Names' in a 2018 edition of *The Spectator*, a street was originally a paved road, such as those constructed by the Romans. By the early twelfth century, a street had to be wide enough for two carriages or sixteen knights on horseback. The word 'road', in the context of a way or path, did not come into use until the late sixteenth century. It tended to mean a route that led between one place and another, whereas a street was a thoroughfare inside a town or village. Names were originally informally descriptive, as in 'the road to London' or 'the London road', which later became formalised as 'London Road'.

The convention of naming roads for their geographical description clearly operates in Southend. London, Rayleigh and Rochford Roads have been shown in a different highlighted colour because the towns they lead to are off the map. What are now Eastwood Road and Eastwood Road North branch off from London Road and lead to Eastwood. There is a branch off those to the sixteenth-century Bell House farm, now the Bellhouse inn. This road is these days split horizontally in two by the Southend Arterial Road (A127) and it consequently has a different name for each of its two sections: Bellhouse Lane/Crescent for the southern end and Bellhouse Road for the northern end.

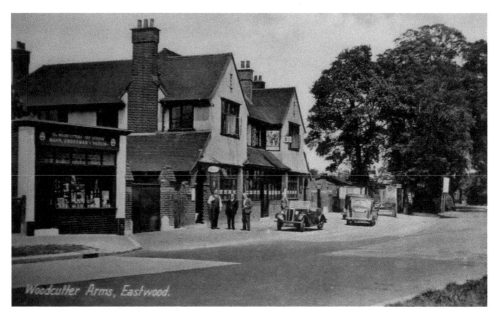

The Woodcutters Arms, which stands at the key historic road junction of what are now Eastwood Road North and Bellhouse Lane.

The Bellhouse, formerly a farmhouse, which gave its name to Bellhouse Crescent, Lane and Road.

Beyond the Bellhouse, Nobles Green Road leads to a lost Eastwood hamlet called Nobles Green. Donald Glennie described it in *Our Town: An Encyclopaedia of Southend-on-Sea and District* (1947) as 'a well-wooded village'. The two roads which disappear off the top of the map either side of the words 'Nobles Green' lead to Flemings Farm and Blatches Farm and are consequently now called Flemings Farm Road and Blatches Chase, respectively.

Before substantial development in this area in the late twentieth century, what are now Nobles Green Road, Flemings Farm Road and the small section of Green Lane which runs between them were collectively called Nobles Green Road.

The next branch off the London Road east from Eastwood Road is Elm Road, named from the Adams Elm, a large tree which can be seen on the map at the London Road junction. The nineteenth-century local historian Philip Benton records in his book *The History of Rochford Hundred* (1867–88) that at the beginning of that century the tree began to rapidly decay and gradually lost its branches and became a hollow shell. It was 30 feet in circumference at the time and could hold a dozen men inside it. The tree had gone by c. 1840, 'since which', wrote Benton, 'all attempts to replace it by a successor have been frustrated'. The Elms public house, which was once a farmhouse, now stands at this road junction, though the name 'Adams Elm House' has been given to a nearby retirement home.

Only one milestone on the map survives: a 39-mile marker which is now in the front garden of the much later 164 Elm Road. This can be seen to the right of the bend in Elm Road, but without the usual '39M' annotation.

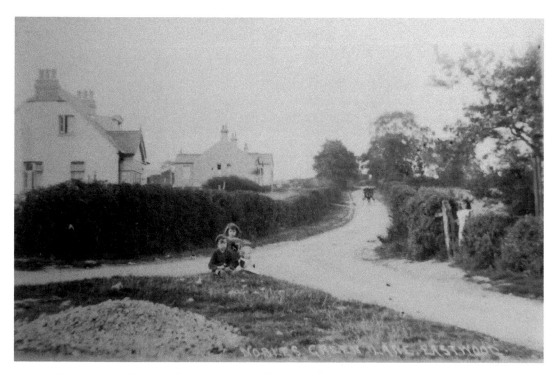

Nobles Green Road (formerly Lane) in the early twentieth century, looking uphill towards the lost hamlet of Nobles Green.

Elm Road in Leigh, showing at left the white 39-mile milestone marker which is now in the garden of 164 Elm Road.

Elm Road leads into Leigh Hill and ultimately into Leigh ('LEE' on the map). Buildings in what is now Old Leigh can be seen clustered along the riverside street, now the High Street. It can be seen from this that Leigh Hill is so named because it leads to the original settlement.

To the east of Leigh Hill stands Lee Hall, accessed from them by a route that was originally called Hall Road but is now the western part of The Broadway and the southern section of Leigh Hall Road. Leigh Hall was the manor house for the parish. The building shown on the map dated from 1561. It was demolished in 1907, but its name has been preserved in the street name.

Next to leave the London Road is Leigh Road, whose original course had a sharp bend where Old Leigh Road meets Kings Road now. Old Leigh Road and the western section of Kings Road were originally part of Leigh Road, but these sections were bypassed in 1901 by the flat, straighter section which connects the northern end of Old Leigh Road and the western end of Kings Road. This section was constructed because trams from Leigh to Southend could not navigate either the steep hill or the sharp bend at the bottom of the original Leigh Road.

Until c. 1915 the section of London Road east of Chalkwell schools, all the way into Southend, was also known as Leigh Road. The Borough Council's Highways & Works Committee minutes of 23 July 1914 record a discussion about this. The Committee's

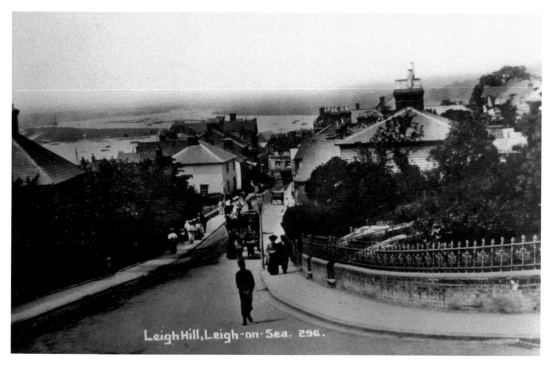

Leigh Hill, the original way into the historic waterside settlement of Leigh.

The route of the original Leigh Road (left) and the 1901 section (right) which replaced it.

Outdoor Sub-Committee recommended that 'the Main London Road between the Victoria Corner and the Hadleigh Boundary be re-named London Road throughout, and that the occupiers of premises on this route be given notice that the name will be changed in twelve months from the date of the notice, and that as far as necessary the numbering of the premises will be altered'. In 2008 a road sign bearing the old name, Leigh Road, was found hidden on the wall of the Cricketers in Westcliff during a refurbishment of the building.

Next up, to the east on London Road, is a lane to Brickhouse Farm, the house for which stood where Leigh fire station is and was replaced by it in the 1960s. This thoroughfare, which was originally called Eastwood Lane, has been renamed into sections: Southbourne Grove (southern end), Eastwood Lane South, Eastwood Boulevard, Kenilworth Gardens (a short stretch to the west of Eastwood Boulevard), the access road for Westcliff High Schools (north of the main school buildings) and Middlesex Avenue (northern end). The presence of the names Eastwood Lane South and Eastwood Boulevard may be surprising here, as most people would think of the area as Westcliff or Chalkwell now, but the map shows why they have Eastwood names: because they led towards Eastwood (the full route to which was completed later).

Staying with Eastwood there is, towards the top of the map, Eastwoodbury Lane, which led to a lost building called East Wood Bury. This was the manor house of Eastwood. It was demolished in 1954 and its site is now under the runway at Southend Airport.

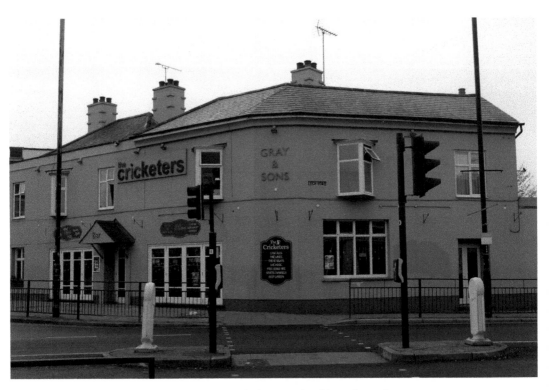

The Cricketers, in what is now London Road, showing the old Leigh Road name sign.

The section at the northern end of the historic Eastwood Lane which has been downgraded to provide an access road for Westcliff High Schools.

It can be seen from the map that the northern half of what is now Eastwoodbury Crescent was part of the original Eastwoodbury Lane.

South of these there is Colemans Avenue, which led to another lost building, Coleman, or Coleman's Farm, in Prittlewell. The farmhouse was demolished in the twentieth century and its land sold for development.

Next on London Road is Milton Road, which led to a lost hamlet called Milton. 'Milton' is a corruption of 'Middletown', it originally being the middle town on the coast between Leigh and Southchurch. Milton was once a sizeable port and shipbuilding centre but was undone by coastal erosion, losing much of its land, and apparently its church, to the sea. Originally a separate parish, it was gradually subsumed into Prittlewell, though not completely until around 1866. Its manor house, Milton Hall, can be seen on the map. It stood where Nazareth House is now. Glennie writes that until it was absorbed by Southend c. 1860–80, the village was known as Milton Hamlet. He adds that The Hamlet was a name for Milton which was '"plugged" by speculative builders in c. 1870-99 because they thought it sounded more select than the real name'.

Sutton Road enters at the top of the map and leads south past Prittlewell to Southchurch Road, so named because it is the road to Southchurch. From Southchurch Road there is a route south into Southend. This route has a kink in it, on its western side. The road here has subsequently been bypassed, widened and straightened into the modern Southchurch Avenue, but the kink survives as Old Southend Road.

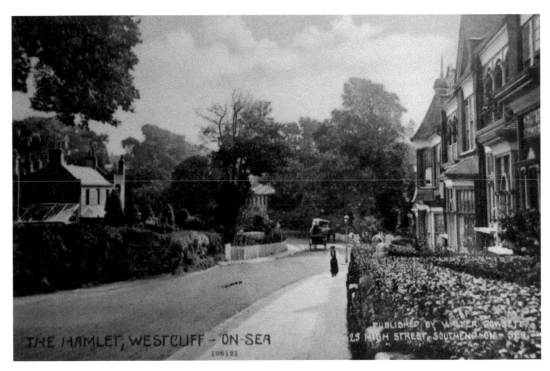

The Hamlet, *c.* 1908, when it had been transformed from the historic parish of Milton into the Southend suburb of Westcliff-on-Sea.

Old Southend Road, once a part of the original route into South End.

Returning to Southchurch Road, one sees that its eastern section beyond the Parsonage and parish church is now named Southchurch Boulevard, of which more later. Off that, to the north, runs what is now Wick Chase, leading to South Church Wick.

Southchurch Wick (as it became) was one of the many farmhouses in the largely rural area which pre-dated South End. The manor of Southchurch Wick was created out of the manor of Southchurch Hall *c.* 1650. Its farmhouse was part-sixteenth/seventeenth century and part-Victorian. It was Grade II listed and owned by Southend Borough Council's Amenities Committee for the last part of its life. After their last tenants left in spring 1977 it suffered vandalism and neglect and began to deteriorate. There was talk that it might be restored, but in June 1977 it caught fire, an event which sounded its death knell. The Borough Architect reported to the Amenities Committee on 9 June 1977 that 'the fire had left a large part of the building in a dangerous condition and as the officer responsible for its stability [he] had given instructions for its demolition notwithstanding the fact that demolition of a listed building without consent was an offence'. The committee retrospectively endorsed his actions and took steps to seek formal approval for demolition.

Not everyone was happy with this. The council's own Planning Committee recorded its disapproval and the South End Area Conservation Society accused the council of poor maintenance and 'gross neglect'. The Leigh Seafront Action Group also objected, noting that a substantial portion of the original structures remained despite 'recent vandalism both civic and private'. It was all to no avail, however, and Southchurch Wick went

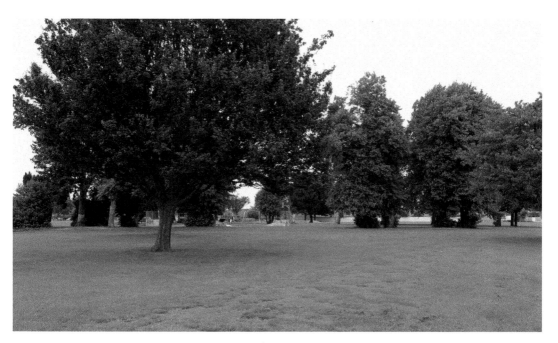

The site of Southchurch Wick farmhouse in what is now Bournes Green Park, showing in the unusual grass pattern which runs from bottom-left to centre-right the route of the original carriage drive to the property.

the way of numerous other local historic buildings, lost to demolition and an ardently progressive and development-minded local authority.

North of South Church Wick on the map is a house called Ravels. This name was subsequently corrupted to 'Rebels' and is the source of the name of Rebels Lane. The original building has gone, but a house of the same name occupies the site. Rebels Lane is accessed by road from Southchurch via Wakering Road, the road to Wakering.

To the south is Thorp Hall, now spelt 'Thorpe Hall', which gives its name to the dual-carriageway boulevard of Thorpe Hall Avenue, which is wider and straighter than the road shown on the map but follows essentially the same course. That road was known until c. 1914 as Thorpe Hall Lane. Thorpe Hall, which dates from 1668, has been home to Thorpe Hall Golf Club since 1907.

To the east of Thorpe Hall are Shoebury Road and North Shoebury Road, which unsurprisingly lead to those places. On the coast to the south there can be seen South Shoebury Common, which has a road running across it. Commons were traditionally used for the grazing of animals and the collecting of brushwood for fuel. Another one can be seen at South End. The road across South Shoebury Common is unsurprisingly now called Shoebury Common Road.

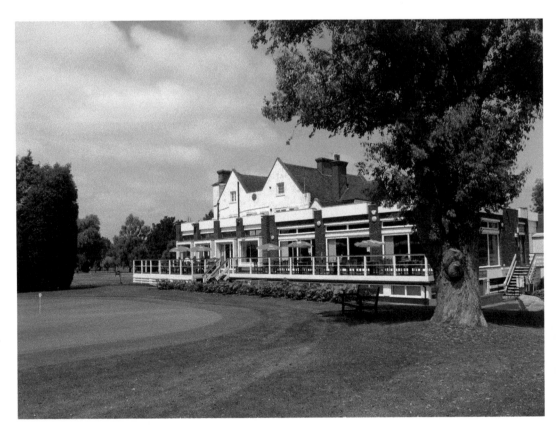

Thorpe Hall Golf Club, showing the upper storey of the original seventeenth-century manor house behind the modern extensions.

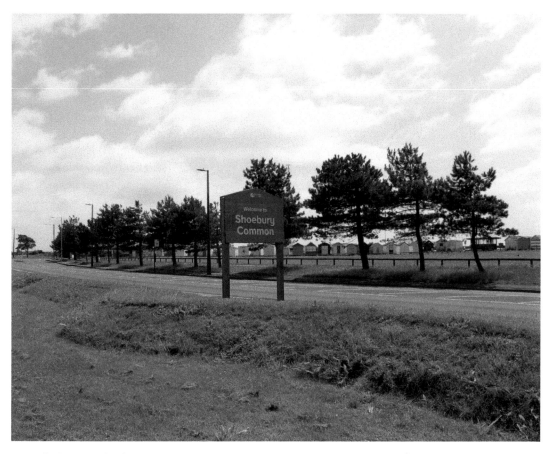

The historic Shoebury Common, showing Shoebury Common Road which cuts across it.

Finally, on the east coast, is Suttons Road. This is named for the manor house of Suttons, which was built in 1681 and whose lands were probably carved out of those of South Shoebury Hall, which can be seen to its south-west. Suttons was the preferred home of the last Lord of the Manor, Dale Knapping, who owned both properties. The current building replaced an earlier one which may have had a larger footprint. In c. 1890 several local farms were acquired by the military for the construction of the New Ranges firing range; Suttons was one of those. Since then, Suttons Road has been closed to the public and has been replaced by the parallel Wakering Road, which opened in 1891 – this is a different Wakering Road from the one from Southchurch mentioned above.

Compass directions have also been historically applied to road names. The three that intersect in the middle of Prittlewell on the map are West Street, East Street and North Street. The first two retain their original names, but North Street has been renamed as it now forms part of Victoria Avenue, which was opened in 1889. The road connecting West Street to Milton is North Road, named 'North' from a Milton perspective. Beyond that point, West Street becomes West Road.

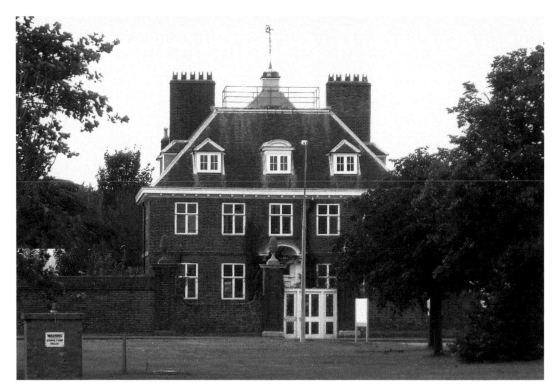

Suttons manor house, showing Suttons Road passing in front of its gates.

## DID YOU KNOW?

The names of Southend, Southchurch and Eastwood all derive from compass directions. Southend originated at the south end of the manor of Prittlewell Priory. Southchurch is probably so named because it possessed the southernmost of the three earliest churches in south-east Essex, the other two being at Prittlewell and Great Wakering. Eastwood takes its name from its location to the east of the historic woodland of neighbouring Rayleigh.

When seen like this in the context of its original, very spartan, layout, it is obvious why the historic road network within the Borough is laid out as it is and why it has certain street names now. It is likely that many of the above routes date – unchanged – from the Saxon period.

## Modern Streets Using Historic Names

The hamlet of South End began to evolve into the town of Southend during the first half of the nineteenth century. The main driver for rapid growth, however, was the arrival of the railway in 1856, which brought both tourists and many permanent settlers.

In 1801 South End was a hamlet within Prittlewell parish; by 1901 it was the dominant settlement within it, with suburbs of Westcliff, Chalkwell and Prittlewell itself. It had also expanded into neighbouring Southchurch.

As Southend grew, more roads were laid out and they and their accompanying buildings gradually infilled virtually all the area on the map from Leigh and Eastwood to North and South Shoebury.

Some of the historic places gave their names to modern streets. Earls Hall, which was one of the original Prittlewell manor houses, gave its name to Earls Hall Avenue and Earls Hall Parade. The house stood just north of what is now Burr Hill Chase, where the Cecil Court tower block is. A request to save the building and a proposal to convert it into a maternity home were both rejected and, in September 1963, Southend Borough Council's Housing Committee asked the Borough Architect 'to prepare sketch plans for the development of the site on the assumption that Earls Hall will be demolished'. The committee duly resolved to demolish it on 28 September, largely due to the need for housing in the town caused by a lengthening waiting list, redevelopment elsewhere and an increasing number of HM Customs & Excise employees. No sign of the house remains, but a section of the property's garden wall survives in Victoria Avenue.

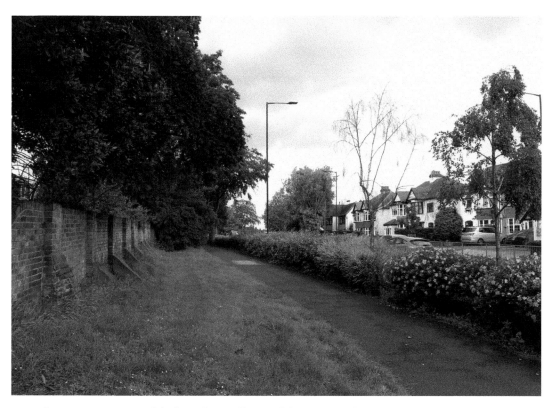

The surviving section of the boundary wall around the grounds of Earls Hall, hiding innocuously in plain sight next to the busy Victoria Avenue.

The Priory (Prittlewell Priory), which stands opposite Earls Hall, gave its name to Priory Crescent and Priory Avenue. Porters gave its name to the adjacent Porters Grange roundabout and underpass. Lapwater Hall in Leigh was demolished in 1947 and a residential street called Lapwater Close was laid out across its site. Cockethurst Close, which was laid out on land in what would now be considered Westcliff but was historically in Eastwood, is named after Cockethurst Farm in the latter parish, which is shown on Chapman & André's map as 'Coxthyheart'. Bridgewater Drive, which it abuts on, was originally called Cockethurst Avenue.

South Church Hall on the map gives its name to Southchurch Hall Close. The Parsonage shown in Southchurch gives its name to Southchurch Rectory Chase. The Crow Stone, offshore beneath London Road, is a boundary marker for the Port of London Authority which gives its name to Crowstone Road, Crowstone Close and Crowstone Avenue. Leigh Hill Close and Milton Avenue take their names from places already discussed.

# 2. Historic Boundaries and Boundary Markers

The Borough of Southend comprises all or part of eight historic parishes. When it was established in 1892 it covered only Prittlewell. In 1897 it was expanded to include Southchurch. In 1913 it was expanded again to include Leigh and part of Eastwood. In 1933 it was expanded again to include South Shoebury, the western half of North Shoebury, another part of Eastwood and some small parts of Great Wakering and Shopland.

## DID YOU KNOW?

Parish boundaries were historically of great importance; the issuing of poor relief, the provision of schooling and the allocation of charitable funds were all administered in accordance with, and dependent upon, a person's parish of birth. They were also used to ratify a person's liability for the repair of the church, the payment of tithes or land rents and the right to be buried in the parish's churchyard.

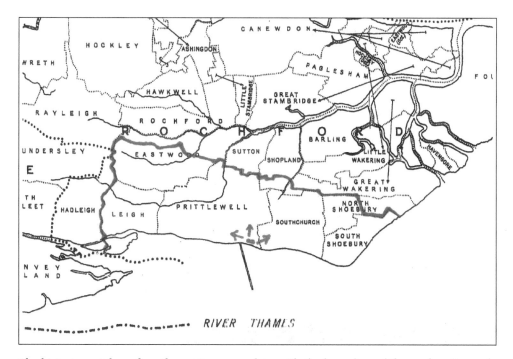

The historic parishes of south-east Essex, overlain with the boundary of the modern Borough, showing where Southend began and its ultimate extent.

Professor Angus Winchester, author of *Discovering Parish Boundaries* (2000), has written that 'the network of territorial boundaries has generally been a stable element in the landscape and ... [is] among the most durable legacies from Anglo-Saxon England'. Parish boundaries set up by the Anglo-Saxons formed an invisible web across the landscape which 'bound families into communities and divided communities from one another'.

Before maps existed, an annual ceremony was held in many parts of the country in which parishioners walked the boundaries of their parish, marking them at certain points as they went. This ceremony, which was generally led by a church official, was called 'Beating the Bounds' and usually took place in Rogation Week or on Ascension Day (late April/May). Prayers were said at certain parts of the route to bless the parish, its inhabitants and the harvest. The perambulation often included the whipping of small boys or the banging of their heads on certain significant posts and trees, so that they remembered where these markers stood. Participants often took long sticks with them to beat the boundaries physically at certain points.

The Anglo-Saxon boundaries remained largely unchanged until the nineteenth century, when substantial urban growth took place and the old pattern of local government boundaries was altered to create civil parishes appropriate to modern requirements. Winchester found that 'this is particularly true where urban growth has made earlier administrative units redundant and it is important when studying boundaries in a local area to recapture the pattern as it existed before these modern changes'. The area covered by the Borough of Southend provides a great example of this: the parish boundaries remained largely unchanged from *c.* 700 until the growth of Southend in the mid-nineteenth century.

## Parish Boundaries

Most historic boundaries around Southend were determined by geographical features, especially rivers; the eleven south-easternmost mainland parishes in Essex (eight of which were included in full or in part within the Borough) had a river as at least one of their boundaries. Other boundaries included roads, tracks, hedges, fences, ditches, prominent trees (usually oaks) and man-made boundary markers, often with appropriate inscriptions on them.

A Beating the Bounds ceremony in Prittlewell on 8 May 1823 included marking several large oak trees and 'the brow of the ditch, near to the place where two trees stood before'. At Smither's Farm the boundary went 'through the kitchen of the said farmhouse' which straddled the border with Sutton. A similar thing happened at nearby Temple Farm.

A perambulation around Southchurch parish *c.* 1830 included a boundary 'where there is the evident appearance of an old ditch'. On 2 April 1838, a perambulation of North Shoebury's boundaries included walking 'along a hedge', 'to a boundary post', 'along the ditch' and 'in a line with the two posts on the saltings'. Benton found that marks on trees in North Shoebury 'were deepened occasionally by the man appointed to carry a hatchet'.

In Shopland in 1817 participants went 'west to X mark on ash tree in the hedgerow about a rod too much – there not being any tree nearer the corner'.

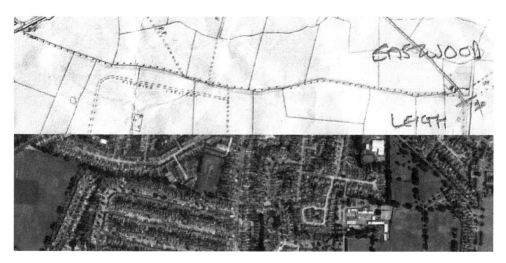

The historic parish boundary between Eastwood and Leigh, highlighted in pink on the Second Edition Ordnance Survey Map (1898) and shown surviving as a treeline between houses on Google Maps (2017).

It is possible, through using accounts like these and contemporary maps, to retrace the boundaries of the historic parishes. Although many have been lost to development, especially in the south of the Borough, it is still possible to trace some of their lines on the ground.

## Borough Boundaries

As Southend grew and absorbed historic parishes, the question arose of maintaining historic boundaries. In 1902 the Assistant Overseer of Southchurch outlined to the Southchurch Parish Vestry – the parish's lowest level of local government – the desirability of having boundary posts 'to perpetuate the limits of the Parish which were becoming undefined owing to the constant alterations through Building Estates being developed'.

The question of putting down boundary markers to identify the Borough's limits (rather than the boundaries of the historic parishes) first arose in 1906, when the council received a letter from Mr B. G. Thomas, Rate Collector, suggesting that stones should be erected at the boundaries of the Borough. The council was supportive of this idea and the Town Clerk was instructed to contact neighbouring authorities to seek part-payment towards it. Shoeburyness Urban District Council agreed to contribute 10s for each post erected between the Borough and the Urban District, and in 1908 the Borough Surveyor was instructed to begin placing the posts.

The markers erected were made of cast iron, four-sided and each around 30 inches high. Some had pointed tops, while others were flat with holes in the top. There are at least fifteen such markers surviving, as listed below. At least six adorn the 1897 Borough boundary (the markers themselves are later). They usually have 'Borough of Southend on Sea' and the date of the marker written on one side and the name of the adjacent local authority on the directly opposite side. The other two sides are usually blank.

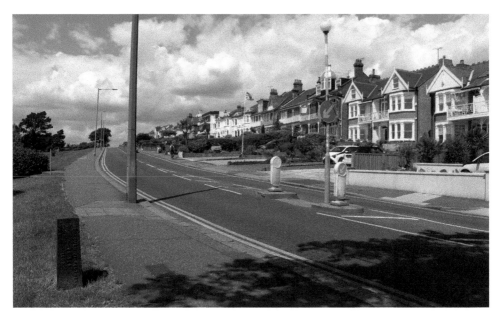

The 1908 Borough boundary marker on Cliff Parade in Leigh, showing the words 'Borough of Southend on Sea 1908'.

## *Boundary of the Borough with Leigh Urban District*
South side of Cliff Parade, eastern end (historically the Prittlewell/Leigh boundary, dated 1908, Ordnance Survey Landranger eight-character grid reference TQ84628565).

Beneath the Gypsy Bridge (Prittlewell/Leigh, badly sea-worn and impossible to read, TQ84648557).

The Borough boundary marker (centre) beneath the Gypsy Bridge, heavily sea-worn, illegible and now part-buried in the sea wall.

The 1908 Borough boundary marker in the central reservation of Blenheim Chase.

In Blenheim Chase, near the fire station (Prittlewell/Leigh, 1908, TQ84988725).

## *Boundary of the Borough with Rochford Rural District*
In Sutton Road by Smither's Chase (historically the Prittlewell/Sutton boundary, 1918, TQ88538817). The wording is, unusually, on adjacent sides, rather than on opposite ones.

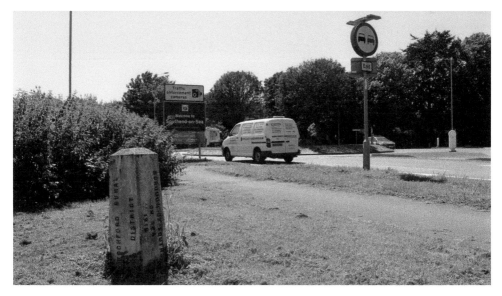

The Borough boundary marker in Sutton Road at Smither's Chase, showing the modern boundary sign behind it.

The Borough boundary marker (left) in Rebels Lane.

In Rebels Lane (historically the Southchurch/Shopland/Great Wakering boundary, 1913, TQ90568748).

## Boundary of the Borough with Shoeburyness Urban District

South of Shoebury Common Road, east of Maplin Way (historically the Southchurch/South Shoebury boundary, 1908, TQ92188436). The word 'Shoeburyness' has been erased from this marker, probably in 1933 when that Urban District's lands were incorporated into the Borough.

In 1913 the Borough was extended to include Leigh parish and part of Eastwood. At least three markers survive from this extended boundary.

The 1908 Borough boundary marker on Shoebury Common.

## *Boundary of the Borough with Rochford Rural District*

In London Road at Leigh, west of Tattersall Gardens (historically the Leigh/Hadleigh boundary, 1913, TQ82118663). There is a plaque on a post alongside it which records the extent of the Manor of Southchurch in 1832.

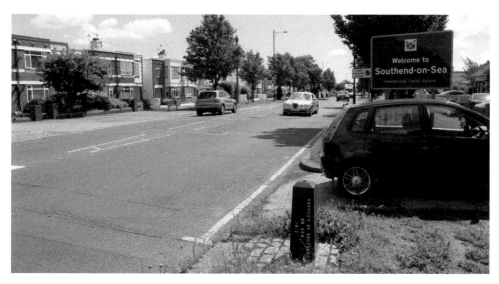

The 1913 Borough boundary marker in London Road, Leigh, showing the words 'Borough of Southend on Sea 1913' and, in the background, the modern sign at the same boundary.

In Bellhouse Lane, north-east of Wood Farm Close (no historic boundary, 1913, TQ83798790).

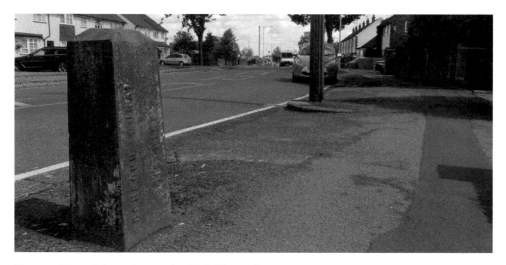

The 1913 Borough boundary marker in Bellhouse Lane.

The 1913 Borough boundary marker at Kent Elms.

In Rayleigh Road at Kent Elms, east side (no historic boundary, 1913, TQ84878833).

In 1933 the Borough was extended again, to include another part of Eastwood, all of South Shoebury, the western half of North Shoebury and some small parts of Great Wakering and Shopland parishes. At least six markers survive from this extended boundary. They feature the words 'County Borough of Southend-on-Sea', following the council's promotion to County Borough status in 1914. All are undated.

## Boundary of the Borough with Benfleet Urban District
In Eastwood Old Road, north-west of Woodside (historically the Eastwood/Thundersley boundary, TQ82738875).

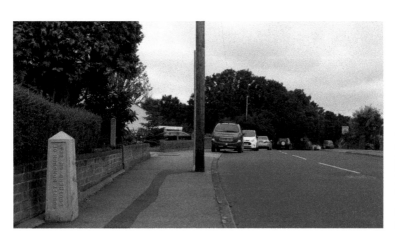

The 1933 Borough boundary marker in Eastwood Old Road, showing the 'County Borough of Southend on Sea' wording.

## Boundary of the Borough with Rayleigh Urban District

South side of the A127, west of Wayletts (historically the Eastwood/Rayleigh boundary, TQ82508904).

The 1933 marker in the undergrowth (left) of the westbound carriageway of the A127 at what is often referred to as 'the Borough boundary'.

In Eastwood Rise, north of Gravel Road (no historic boundary, TQ83138964).

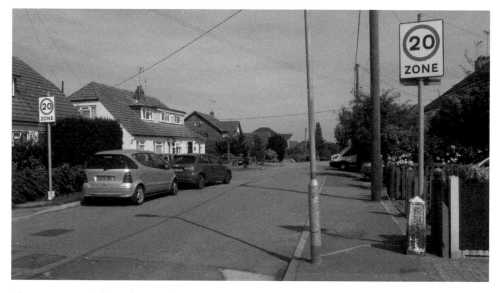

The 1933 Borough boundary marker in Eastwood Rise.

## Boundary of the Borough with Rochford Rural District

In Flemings Farm Road, just off Green Lane (no historic boundary, TQ84208939).

South side of Poynters Lane, at the junction with Star Lane (no historic boundary, TQ93368674). This marker is largely buried. The visible above-ground lettering – 'B' for 'BOROUGH' – is consistent with the pre-1933 wording (laid out in three lines as 'Borough of Southend/on Sea/date', reading downwards), but the marker stands at a 1933 boundary (at which markers usually have 'County Borough of/Southend-on-Sea' laid out in two lines, reading upwards). The nearby Southchurch/North Shoebury boundary three-quarters of a mile or so to the west in Shoebury Road (Southchurch) should have a 1908 boundary marker on it, but there is not one there. It is possible, even probable, that that marker was moved to Poynters Lane in 1933 when the Borough was extended eastwards. It is odd that the marker is buried so deeply in the ground. Perhaps there was a slope here which was levelled when the area was developed in the 1980s and the marker was part-buried in the process.

The 1933 Borough boundary marker in Flemings Farm Road.

In Wakering Road (Shoebury), north of Constable Way (historically the South Shoebury/ North Shoebury boundary, TQ94558621).

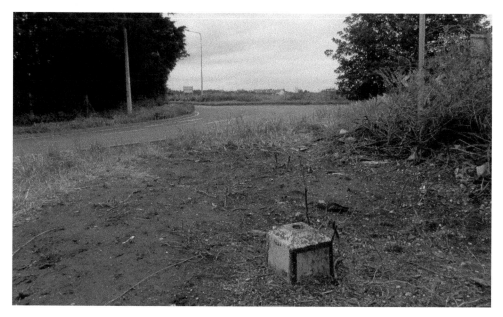

The part-buried 1933 Borough boundary marker in Poynters Lane, showing Star Lane and Great Wakering in the background.

The 1933 Borough boundary marker in Wakering Road, Shoebury, which stands on the verge alongside a concrete block; note the speed limit change, which on the edges of the town are often a sign of a historic boundary.

It has not been possible to locate a full list of all the Borough boundary markers that were installed. Two were erected, for example, within the Ministry of Defence area on the historic boundary of South Shoebury and North Shoebury: they are mentioned in the minutes of Southend Borough Council's Highways & Works Committee in 1934 as being on land belonging to the War Office there. The current occupants of the site, QinetiQ Defence & Security Contractors, have advised the author that neither post is now in place. Others elsewhere may have been removed during road widening or junction realignment. More may survive, hidden in hedgerows. Some of the above were difficult to find!

Professor Stephen Rippon, who has studied the local landscape in depth, has written of 'the remarkable time-depth that is present within the modern pattern of settlements, roads, fields and land-uses'. The historic streets and boundaries of the Southend area confirm that this is the case within and around the Borough.

# 3. Trams & Boulevards

The Light Railways Act 1896 made it possible for local authorities to consider the introduction of trams in their areas. Southend Borough Council was an early advocate of this new form of transport and quickly took steps to introduce it. Trams went hand-in-hand with electricity and, as the tramway network grew, so did the use of electricity in streets, homes and businesses.

The first trams in Southend ran on 19 July 1901. The first routes included Southend High Street to Prittlewell, Prittlewell via West Street and North Road to the Cricketers, Southend High Street to Southchurch and a branch line from the latter route down Southchurch Avenue to the Minerva pub and the Kursaal.

The tramway depot and electricity generating station were constructed west of the town centre and north of the London Road, where Lidl is now. There is still a generating station on the site. Some of the fencing along the eastern edge of the site also dates from the time of the trams.

The trams were immediately popular. Their success prompted the construction of a longer route from Southend High Street to Leigh, which extended at the time beyond the Borough boundary into Leigh Urban District. The route along Leigh Road required the construction of the new, straighter, flatter section discussed in the chapter on street names.

In 1908 the council opened its first seafront service, from the Minerva to Bryant Avenue and back. This was extended in 1909 to the Halfway House pub, so named for its location halfway between Southend and Shoebury.

Perhaps the most ambitious scheme that the council constructed was a circular 'tour' which ran north from the Minerva up Southchurch Avenue, east along Southchurch Road to the White Horse and beyond that into what was then open countryside as far as Bournes Green and then south down an extended Thorpe Hall Lane (later Avenue) to the shore and then west along the seafront to the Halfway House and the Minerva. The seafront section of the route opened on 6 February 1912.

The scheme included the construction of two new broad, picturesque, shrub-planted, dual-carriageway roads: Southchurch Boulevard, on the eastern section of the old Southchurch Road; and Thorpe Hall Boulevard on the route of Thorpe Hall Lane/Avenue. It also included the widening of the railway bridge over the latter section. The trams would run down the central reservation, with horse and then comparatively rare motor traffic using the roads. Southchurch Boulevard opened for business on 30 July 1913. Thorpe Hall Boulevard took longer because of the work to widen the railway bridge and opened on 16 July 1914, the date on which the full circular route came into operation. The name 'Thorpe Hall Avenue' was soon applied to this section.

The circular route proved immediately popular with tourists and the council showed much foresight in building wide thoroughfares here that would later have to accommodate

considerably higher levels of traffic. V. E. Burrows, author of *The Tramways of Southend-on-Sea*, has described the move as 'bold and sensible planning'. Glennie has described the section around Bournes Green as 'probably the most beautiful tramway in England'.

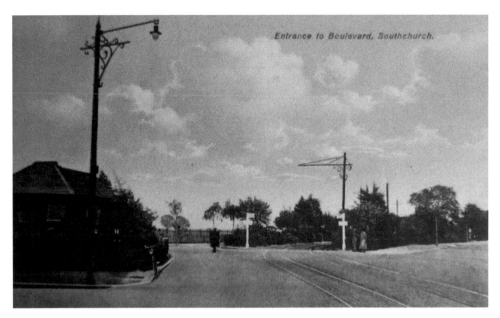

The entrance to Southchurch Boulevard from Southchurch Road, showing the central route for trams and the road carriageway either side of it.

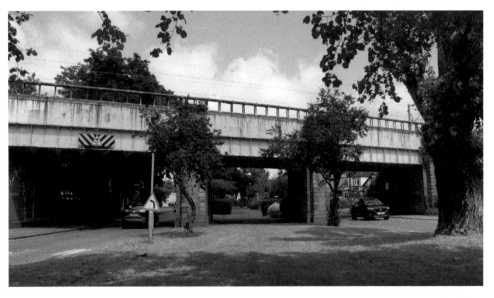

Thorpe Hall Avenue, showing the now unused central span of the railway bridge through which trams ran from 1914 to 1938.

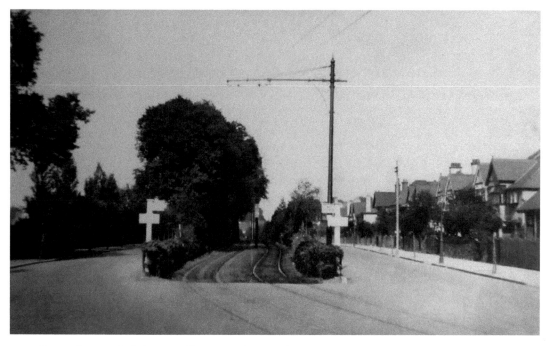

The southern end of Thorpe Hall Avenue, showing the tram tracks in the centre.

The trams were at their peak in the mid-1920s. From then onwards they began to be replaced, initially by trolleybuses (1925–54) and then increasingly by petrol-engined motor buses which did not need tracks or overhead wires and were consequently not restricted to specific routes. The last tram ran on 8 April 1942, with the boulevard service being discontinued on 6 July 1938.

Although the trams have gone, Burrows has described the boulevards as 'a silent memorial' to them. Most of the tramway trackbed can still be made out and two electricity substations which were installed for tram operations also survive, one in a clump of trees in the central reservation at the eastern end of Southchurch Boulevard and the other next to Burges Road at the southern end of Thorpe Hall Avenue.

The introduction of trams did much to stimulate growth in hitherto undeveloped areas of the town. It also provided the council with a development model for a new type of thoroughfare – the boulevard.

## Interwar Boulevards

The interwar period saw the commissioning of several road improvement schemes in Southend, including on the major routes of London and Sutton Roads and on many of the other historic roads in the area. In many cases, improvement was achieved by the widening of existing thoroughfares into boulevards. The latter consequently became a leading road design option in the town in the 1920s and 1930s. Below are some examples of the tramway-inspired boulevards which were constructed during this period.

First up was the conversion of a section of the historic Eastwood Lane into a new Eastwood Boulevard, a name first mentioned in the minutes of Southend Borough Council's Highways & Works Committee on 18 April 1918, when Councillor Neil offered 'to provide two further seats to be placed in Eastwood Boulevard'. This area was on the edge of the town at the time, but the tentacles of development were extending in its direction and the council had already been taking steps to acquire land adjacent to the Lane to allow for road widening, including the bridge over Prittle Brook.

In December 1919 the above committee received a letter from a Mr Howe 'with reference to the renaming of Eastwood Lane opposite Chalkwell Park'. The Borough Surveyor was instructed to arrange for the section of Eastwood Lane north of Chalkwell Park to be renamed 'Southbourne Grove'. It is presumed that the next section was renamed 'Eastwood Lane South' at or around the same time.

Although the section beyond that was named as a Boulevard, a development which should have brought with it a dual carriageway with a central reservation, the design was evidently not completed as envisaged, as only the eastern carriageway was constructed. Nevertheless, in December 1923 the Borough Surveyor was directed to fix boards 'in suitable positions in Eastwood Boulevard from Kingsway to Prittlewell Chase with the name "Eastwood Boulevard" inscribed thereon'.

As discussed in the chapter on street names, the original Eastwood Lane turned west at the top of the part now called Eastwood Boulevard and forms the access road for

Eastwood Boulevard, viewed from what was supposed to be the central reservation and showing the planned western carriageway (left) as only partially constructed.

Westcliff High Schools. The final section of Eastwood Lane then turned north from the western end of that access road and has been renamed to form the top end of Middlesex Avenue. It terminated at Brickhouse Farm, which stood where the fire station is. However, Eastwood Lane was later extended northwards to meet Eastwood Road (now Eastwood Road North). That extension, which is shown as 'Eastwood Lane' on maps as recently as the 1950s, has since been renamed Mountdale Gardens. The improvement and extension of Eastwood Lane was key to the development of north Leigh and south Eastwood.

On 9 July 1920 the council's Town Planning Committee was presented by the Borough Surveyor with a plan for 'a proposed new arterial road to run north of Prittle Brook and following roughly the line of Prittlewell Chase [then just a track] leading at its eastern end into Fairfax Drive'. The Committee agreed the route in principle and directed the Borough Surveyor to commence negotiations with landowners in the area.

## DID YOU KNOW?

The terms 'boulevard' and 'arterial road' were used interchangeably in Southend Borough Council minutes in the 1920s for wide, high-capacity roads. The only difference in practice seems to be that boulevards are heavily planted with trees and shrubs to make them more aesthetically pleasing.

In February 1921 the Borough Surveyor reported that, for the first section of this proposed route, from Southbourne Grove to Eastwood Boulevard, he was planning to provide 'a road 100 feet wide, having a plantation or enclosure running along the centre of the thoroughfare with a carriageway and a footpath on each side thereof similar in style to the layout of Thorpe Hall Avenue'. Only one carriageway was to be opened initially, to save on costs.

The road opened towards the end of 1921. It was soon given a new name, first mentioned in the council's minutes in November 1922: 'Kenilworth Gardens, Prittlewell Chase (the portion of Prittlewell Chase lying between Southbourne Grove and Eastwood Lane [Boulevard])'. It was dualled in early 1923, by which time labour and materials costs had dropped so dramatically that the council was able to complete both carriageways within the already approved budget.

From 1924 onwards, the council began buying up land for the widening of the rest of the route eastwards from Kenilworth Gardens towards Southend. It also discussed extending the route westwards to Eastwood Road at Belfairs, a development which would, in due course, lead to the creation of Blenheim Chase. The latter was first mentioned in council minutes in February 1922.

The full Prittlewell Chase/Kenilworth Gardens/Blenheim Chase route was not completed until the late 1950s. The last part to be completed was the section to the north of Westcliff Schools, essentially a bypass for the old Eastwood Lane (school access road).

Kenilworth Gardens, a renamed part of the original Prittlewell Chase track, which in July 1920 was earmarked for development as a boulevard 'similar in style to the layout of Thorpe Hall Avenue'.

Next up for the council's attention was Eastwood Road, another of the historic thoroughfares in the area. The name 'Eastwood Road' applied at the time to the full route shown on the map in the chapter on street names from London Road to Rochford Road and beyond that via Cuckoo Corner (then a bend, not a roundabout) to Earls Hall and the Priory Park gates. This route encompasses what are now Eastwood Road, Eastwood Road North, the section on the map to the north of Coleman's Avenue which runs between Kent Elms and Cuckoo Corner, and which would be widened and then renamed in 1925 to become Prince Avenue (see below), and the northern section of what is now Victoria Avenue.

Work on acquiring land for the widening of this route, starting at the eastern end, began in the second half of 1920. In December that year the chairman of the Highways & Works Committee submitted to the council a proposal 'for the widening and improvement of the road leading from Earls Hall to the waterworks at Eastwood and onwards to join up with the proposed widening of Eastwood Road near [the] Belfairs Estate'. Large numbers of unemployed men were available to work on road-widening schemes at this period, in part due to the demobilisation of thousands of ex-servicemen after the First World War. The national government made grants available to local authorities under the Unemployment (Relief Works) Act. The Eastwood Road (Prince Avenue) widening scheme, the first section of the above to be addressed, had 160 otherwise unemployed men working on it in December 1920 alone.

Progress on the widening work was swift and on 5 May 1921 the Borough Surveyor reported that 'in the course of a few days the widening improvement of Eastwood Road from Cuckoo Corner to Rayleigh Road [Kent Elms] would be completed'.

## DID YOU KNOW?

Realignment of part of the route between Kent Elms and The Bell in the 1990s, to accommodate the new 'Tesco Roundabout', led to the bypassing of the historic section of Prince Avenue (formerly Eastwood Road) between Queen Anne's Drive and Dulverton Avenue. This section, which had by then been dualled, was also returned to single-carriageway status. This is the only part of the historic Eastwood Road route that has been widened, renamed, dualled, singled again and bypassed.

Negotiations were also underway with affected landowners to the west of Rayleigh Road regarding the improvement of Eastwood Road at what is now Eastwood Road North. These included Essex County Council, as Eastwood Road North and Prince Avenue together marked the north-western boundary of the Borough at the time and some of the

Prince Avenue, looking west from Cuckoo Corner, originally the easternmost part of Eastwood Road, a country lane which stretched all the way to where Westleigh Schools are now.

adjacent land was in their jurisdiction. The 1913 Borough boundary markers in Bellhouse Lane and at Kent Elms, which were discussed in the previous chapter, provide additional evidence of this.

The negotiations proved to be a challenge, however, and on 9 June 1921 the Borough Surveyor reported that as he had been unable to arrange terms with affected landowners 'it would be necessary to terminate the work'. In March 1924 the council formally resolved not to proceed with it, although attempts to do so lingered on into 1926.

With issues continuing regarding Eastwood Road North, the council decided to press on with improving Eastwood Road at its south-western (London Road) end. On 7 July 1921 the Highways & Works Committee instructed the Borough Surveyor to arrange that the next instalment of the widening work 'shall be carried out upon the portion of Eastwood Road known as Turners Lane'. This is the section that is still called 'Eastwood Road'.

Two weeks later, the Borough Surveyor reported that this work had commenced on 18 July. Then, in October, the committee heard that a landowner, Mr J. Fowler, had agreed to dedicate to the use of the public 'the piece of ground at the corner of Turner's Road and London Road required for the carrying out of the Eastwood Road Improvement'.

This section was duly widened to boulevard proportions, but no second carriageway was built. Nevertheless, the improvement of Eastwood Road facilitated the development of the Belfairs area, which straddled the boundary between the old Leigh and Eastwood parishes.

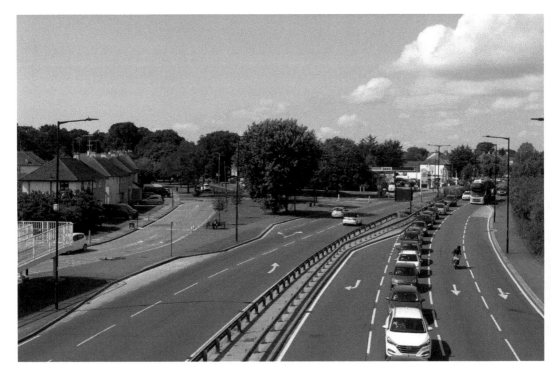

Eastwood Road North (left background, disappearing diagonally into the trees), which before the arrival of the Southend Arterial Road in 1925 (right, now the A127) was the main route in the area.

The Highways & Works Committee had planned to do more. In November 1921 its members instructed the Borough Surveyor to 'negotiate with the owners of land lying to the north of this portion of Eastwood Road so as to enable the widening improvement to be carried directly north and avoid the more circuitous route past Belfairs Lodge and Furzefield [currently The Inn at Belfairs]'. In June 1922 the committee's Outdoor Sub-Committee examined 'the site for the new road from the Woodcutters public house to Blenheim Chase' and recommended that the Town Clerk serve notice on affected landowners.

Negotiations were ultimately unsuccessful, however. In April 1925 the committee resolved that the planned new road 'should not be carried into effect, but that the existing road skirting the west side of the land proposed to be traversed by the new road should be widened'. No route was consequently ever built directly north from Eastwood Road to the Woodcutters, and the historic 'bend at Belfairs' survives as the main thoroughfare in the area to this day.

In November 1921 the council received news that a major arterial road was to be constructed to join the town to London. This was at the request of Sir Henry Maybury KCB, Director General of Roads.

It was believed that the new road would be entering the Borough at 'a point north of the Belfairs Estate and there connecting with the widened Eastwood Road now in the course

The only section of Eastwood Road which retains that name today, showing the widening of the original country lane which took place in preparation for a second carriageway (right) that was never constructed.

of construction'. It was to be 21 miles long and 100 feet wide, with one carriageway of 25 feet in width to be constructed immediately. The work was to commence from both ends and the middle simultaneously and to be completed within six to nine months. The cost of the project was £750,000 and it had been set up primarily for unemployment relief in London.

London County Council and Essex County Council were both contributing funding. The Town Clerk reported that 'as in the view of the Ministry, the road would be chiefly of value to Southend, to which it was suggested it would provide an unparalleled approach from the Metropolis, the Ministry asked that the Council would at once consider the making of a very substantial contribution towards the cost of the work'.

Sir Henry had asked that a deputation from the council attend him on 7 November and several members of the authority did so. They reported back on 11 November. Sir Henry had asked them to contribute £100,000 to the scheme. Councillors agreed to do so.

The Borough Surveyor was directed to ascertain the point at which the new road would enter the Borough. Having met with representatives from the Ministry of Transport and the contractors for the work, he reported that it had been provisionally agreed that 'the new road should enter the Borough at Kent Elms Corner on the Eastwood Road, Kent Elms Corner being the western point at which the Eastwood Road widening improvement has been carried out' (and the north-westernmost point of the Borough at the time).

By 22 December 1921 some fifty local men were at work on the Southend end of the scheme, with another forty requested by the contractor. Several sections of the road were ready by the summer of 1923, but the Ministry of Transport refused to open the whole road until the sections with embankments that were waiting to settle had been completed. Southend's councillors were very unhappy about this and tried unsuccessfully to get the Ministry to open the completed sections.

The road eventually opened in stages between June and September 1924. It was formally opened in full on 25 March 1925 by Prince Henry, Duke of Gloucester. The minutes of the council's Highways & Works Committee of 19 March record that 'It was resolved that the name of the portion of Eastwood Road lying between Cuckoo Corner and the junction of Eastwood Road with the new London to Southend Road [at Kent Elms] be known as Prince Avenue following the opening of the London to Southend Road by H.R.H. Prince Henry.'

It can be seen from the above (and the map in the chapter on street names) that the main historic route in the locality of Kent Elms was Eastwood Road – comprising the renamed and widen sections of Eastwood Road North and Prince Avenue. The Southend Arterial Road was simply plugged into the existing route from the west. It is difficult to understand this today, as the main route has become Prince Avenue and the Southend Arterial Road, conjoined under the national route designation of 'A127', and the Eastwood Road North section has been downgraded to a suburban street.

The Southend Arterial Road was the big daddy of the boulevards in Southend because of its length and regional importance. It superseded the historic London Road (now designated 'A13') by providing a wide, purpose-built route to the Capital, although it wasn't fully dualled until 1939. Southend Borough Council took inspiration from this to construct a brand-new dual-carriageway road within the Borough.

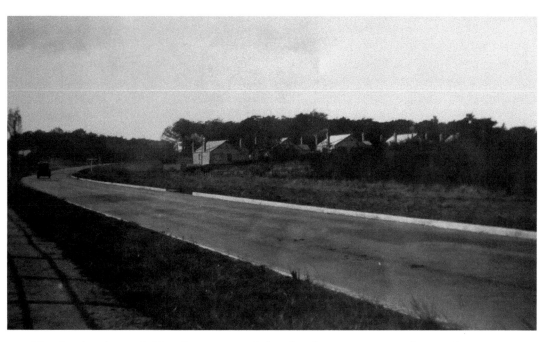

The Southend Arterial Road at Eastwood shortly after its opening, showing how it cut perpendicularly through the historic route to the Bellhouse at what are now Bellhouse Crescent and Bellhouse Road (left and right, respectively).

On 10 March 1922 the council's Town Planning Committee discussed a proposal for a new, 100-foot-wide road from Cuckoo Corner to Bournes Green, which it was envisaged would serve as a northern bypass to the growing town. The Borough Surveyor was as usual instructed to commence negotiations with affected landowners.

On 25 May, the Highways & Works Committee resolved to apply for funding towards the first phase of the project, 'the construction of a new route leading from Cuckoo Corner along the north of Priory Park across the railway and south of the sewage works to Sutton Road and in addition the widening and extension of Brook Road'. This brand-new road through open countryside would in due course become Priory Crescent (northern half) and Eastern Avenue (western section). It would also convert Cuckoo Corner (until then literally a corner or bend) into a junction. Brook Road, the only part of the above that was already in existence, would be renamed and joined up to become the southern half of Priory Crescent, a name which was formally chosen in February 1926. The boulevard-style planting of the route was to commence east of the railway bridge. The latter was also in existence, but it was an 'occupation bridge', for the use only of the occupiers of the land. If it was going to be used for road traffic it would need replacing with a wider, stronger structure. Once again there was clamour for using unemployed local men on the route's construction.

Most of the land on the planned route was owned by the Southend-on-Sea Estates Company Ltd. The council minutes from the time give the impression that they were quite robust in their negotiations. The northern section of Priory Crescent was constructed as

a single-carriageway because of issues in acquiring the necessary 100-foot width needed to accommodate a dualled route. It took until 5 February 1923 for negotiations to be concluded and for work to commence, although forty-four men were employed on the project by 22 February.

A site inspection by the council in April 1923 found that work on what would become Priory Crescent (north) and Eastern Avenue (western section) was progressing well. The land on the western side of the bridge, which was much lower than that on the eastern side, was raised using soil which had been dug for a sewer in nearby Fairfax Drive. Agreement had been reached with the London & North-Eastern Railway (LNER) over arrangements to replace the existing railway bridge, though negotiations around who was to pay for it rumbled on into 1925.

It took until April 1928 for the LNER to accept a tender to construct the bridge. The original bridge was still in use at the time, but the LNER asked in July if it could be closed to traffic for three months to enable the new, wider, one to be built. The council reluctantly agreed to this the following month, with conditions. By September part of the new bridge was ready to be resurfaced and in October the south parapet was complete, with the north one soon to follow.

As with the Southend Arterial Road, this new route opened in stages. On 17 July 1924, the Borough Surveyor was authorised to open for public use 'the portion of [the] Cuckoo Corner Road lying between Cuckoo Corner and the occupation bridge over the railway'. Once the new bridge had been constructed, the first part of what would become Eastern Avenue opened as far as Sutton Road.

The western end of Eastern Avenue, the first part of that road to be constructed, showing the classic boulevard model of a wide, tree-planted central reservation with road carriageways either side.

The second part of what would become Eastern Avenue was initially referred to, in November 1924, as the 'New Road and surface water sewer from Sutton Road to Durham Road', Durham Road being by the parade of shops at the top end of the historic Hamstel Road (formerly Lane) and by the existing kink in that road which can be seen on the map in the chapter on street names. The Eastern Avenue part of this road can also be seen on the map, following the line of an existing route (which was called Stoker's Lane) near to a lost building called Tranham.

In April 1925 the Borough Surveyor was directed to communicate with landowners along the proposed route 'with a view to obtaining from them a letter intimating their agreement to a proposal that in laying-out the new road with a width of 100 feet between the fences, one carriageway only of a width of 24 feet should be provided instead of two carriageways divided by a plantation'. In September he was directed to proceed with the work.

In November, however, the Ministry of Transport wrote, asking why only one carriageway of 24 feet in width was to be built and whether there were any plans for a tramway to be provided along the route. The Borough Surveyor was instructed to reply that the width was on the grounds of 'economy and use', suggesting that money was tight, and that 'the Council had not considered the question of laying a tramway in the widened thoroughfare'. The Ministry of Transport was not satisfied with this and threatened to withhold unemployment grants, adding that 'a central carriageway was the most desirable proposition and that that form of construction would be followed for the whole of the ring road not yet constructed'. This presumably related to the remainder of the full intended route to Bournes Green. The council agreed 'to revert to the original scheme proposed for the laying-out of this widened thoroughfare by the provision of two carriageways of a width of 24ft each divided by a central plantation and to arrange that one of such carriageways only should be provided at the present time'. An unemployment grant was duly forthcoming in January 1926. Work was to be started at once, which it was, and completed by 30 April.

'The New Boulevard' was reported as being under construction in March 1926. The April deadline was evidently missed, however, for in June the Borough Surveyor was directed to defer work on widening the section next to the Jones Memorial Ground, pending confirmation from the Education Committee that he could use part of that ground for road-widening purposes. The name 'Eastern Avenue' was chosen in 1928 for the full route from the railway bridge to Hamstel Road. The remaining section of Eastern Avenue, from Hamstel Road to Bournes Green, now called 'Royal Artillery Way', did not open until the late 1960s.

Related to the Sutton Road-Durham Road scheme was a northern extension to Bournemouth Park Road, which had been laid out from the Southchurch Road end before the First World War but only as far as what is now the Bournemouth Park Academy primary school. It was proposed in 1924 to extend it and make the extension wider, at 80 feet. This was because members of the council's Light Railways and Electric Lighting Committee were contemplating operating a tramway on the thoroughfare. The Borough Surveyor tried unsuccessfully to get approval for the usual 100-foot width.

Hamstel Road looking south towards Durham Road, showing the short stretch of central reservation which may have been associated with a planned boulevard scheme which was never delivered.

Work commenced in May 1925 and the unemployed were once again put to work on the project. Housebuilding on the western side of the extension, north of Shelley Square, commenced in 1926 and shrubberies and pavements were made up at the same time. The work was completed in sections.

The width difference between the pre-1920s road and the post-1924 extension can be appreciated by anyone standing outside the northern end of the Academy.

By the mid-1920s the boulevard model had become so well established that when the private developers of Leigh's Highlands Estate submitted their plans for the road layout there in 1924–26, which was focussed on the brand-new Highlands and Sutherland Boulevards, the council accepted them without question. The names 'Highlands Boulevard' and 'Sutherland Boulevard' both make their first appearance in the council minutes in 1928.

Many more boulevards followed. As early as 1923 the council began buying up land for a planned town centre route to the seafront, which would take until the 1970s to deliver as the eastern section of Queensway (see later chapter). Rochford Road was widened in the late-1920s and Lifstan Way, a new road to the seafront, was constructed wider than required in 1927–30 in case of later need. In 1928 plans were advanced for the widening of the ancient Hobleythick Lane and the equally ancient Sutton Road between Eastern Avenue and East Street. In 1938 Manners Way was constructed to provide a new route

Bournemouth Park Road, looking north from Bournemouth Park Academy (left) towards the 1920s extension which was constructed wide enough to accommodate a planned, but never built, tramway.

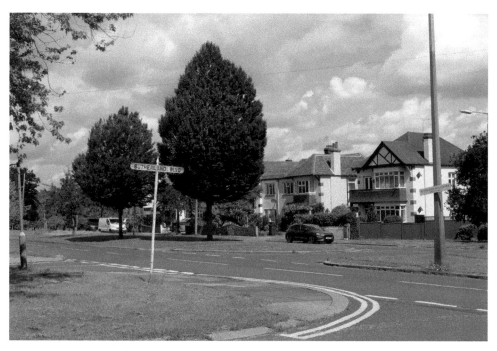

The junction of Highlands and Sutherland Boulevards, the centre point of the Highlands Estate, which was commenced in the mid-1920s.

north from Cuckoo Corner. It, and Oakengrange Drive which bisects it, were both given wide grass verges in case of later need. London Road was also widened, but not to boulevard proportions; the Southend Arterial Road now handled most east-west traffic.

After the expansion of the Borough in 1933, the council widened the historic Rayleigh Road, Whitehouse Road and Snakes Lane in Eastwood, as well as the eastern end of Eastwoodbury Lane. The section of Rayleigh Road outside the Eastwood Academy includes a short stretch of central reservation.

In Shoebury, Bournes Green Chase, a 1970s bypass for the original Shoebury Road, was built wide enough to accommodate a boulevard if required. It even had streetlights with double arms erected on it for that purpose, until that lighting was replaced around the millennium. The historic North Shoebury Road was similarly widened to accommodate a boulevard, if necessary, while nearby Maplin Way was built of boulevard width from scratch.

Except for Southchurch Boulevard and Thorpe Hall Avenue none of the above ever had trams running on them, but the idea for the widespread use of boulevards across Southend clearly came from the success of those two thoroughfares.

The construction of boulevards was a key component of the council's interwar strategy for transforming the existing network of historic country lanes into modern thoroughfares. It was also far-sighted: none of the dual carriageways built in the 1920s needed the traffic capacity they were given. They are still coping (mostly), a hundred years later, with vastly increased levels of traffic.

# 4. The Second World War

Southend played a leading role in the Second World War and was in the firing line throughout the conflict. The Borough Council formed an Air Raid Precautions Committee in 1935, and by the summer of 1939 cellars in public buildings were being strengthened for use as air-raid shelters and plans were afoot to dam Prittle Brook to create emergency reservoirs for fire brigade use. Air-raid shelters were set up in the by now disused tramway boulevards. Parts of Belfairs, Chalkwell and Southchurch Parks were ploughed up for food production.

Southend was taken over by the military as 'HMS Westcliff' and was deserted for much of the war. The pier and the airport were both requisitioned, the former being renamed 'HMS Leigh'. The pier was fundamental to the defence of the Thames Estuary. Gun emplacements and searchlights were installed on it and every movement of shipping in the river was logged, including 84,000 ships in 3,000 convoys. This was particularly critical for D-Day, when hundreds of ships were stationed off Southend, waiting for the order to depart.

Weapons testing facilities at Shoebury Garrison also played a leading role in the war, as did the EKCO factory in Priory Crescent, which provided components for military equipment, including radar. EKCO had its own on-site underground air-raid shelters, which have only recently been filled in during redevelopment of the site.

This chapter looks at some of the surviving evidence of wartime Southend.

## Surviving Evidence

In 1939–40 a defensive wooden structure known as a 'boom' was constructed across the mouth of the River Thames from Shoebury to Kent to prevent enemy vessels from entering the river and attacking anchored shipping. Friendly ships were allowed to pass through gates in the boom, which narrowed the channel and provided a mounting point for anti-aircraft guns and searchlights. The boom was replaced by a concrete one in 1950–53 as part of a review of Cold War defences, but rapidly improving aerial technology and weaponry soon rendered it obsolete and it was subsequently partially demolished. A section of this boom is visible at Shoebury East Beach. It comprises a 1.4-mile-long double row of staggered, concrete posts, around 10 feet high, that are linked together with iron. It is believed to be the only surviving defensive barrier across a river estuary in the UK which had its origins in the Second World War.

The first major activity of the war which affected Southend was the evacuation of Dunkirk in May/June 1940. Many local boats played an important role in this. They included the Southend lifeboat *Greater London*, which is believed to be in Uruguay now, and numerous working boats from Leigh. One of the latter, *Endeavour*, has been restored for public display and is usually anchored off the Peter Boat public house in Old Leigh.

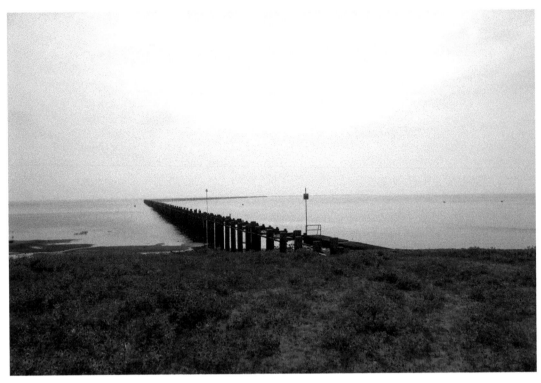

The concrete Cold War defence boom off Shoebury East Beach which replaced a wooden Second World War boom that was designed to prevent enemy shipping from entering the estuary.

An information board there gives details of its history. The ship appeared in the 2017 feature film *Dunkirk*, directed by Christopher Nolan.

Another Leigh boat, *Renown*, was lost when it hit a mine and is commemorated in a well-known memorial in St Clement's Churchyard.

The retreat from Dunkirk led to fears that Britain would be invaded. At Southend, numerous defences were constructed along the seafront and throughout the town, as it offered easy landing access from the River Thames via gently sloping mudflats and easy access to London by road and rail. It also had an airport and flat countryside to the north and east which would be ideal for glider and paratrooper landings. Defences included concrete anti-tank blocks and barbed-wire fences along the seafront, plus road barriers in and around the town, as well as concrete pillboxes at strategic locations and gun emplacements at Belfairs and Thorpe Bay. Key road junctions such as Victoria Circus, Cuckoo Corner, Bournes Green, the Bell and Kent Elms were given comprehensive protection.

Fred Nash, who carried out a *Survey of World War Two Defences in the Borough of Southend-on-Sea* for Southend Borough Council in 2000–01, has written that: 'Every road, alleyway and exit from the seafront into the town was blocked by a concrete and steel anti-tank barrier. Every space between the houses was blocked by steel scaffolding or a wide anti-tank ditch. From Chalkwell to Thorpe Bay every house was an anti-tank obstacle.'

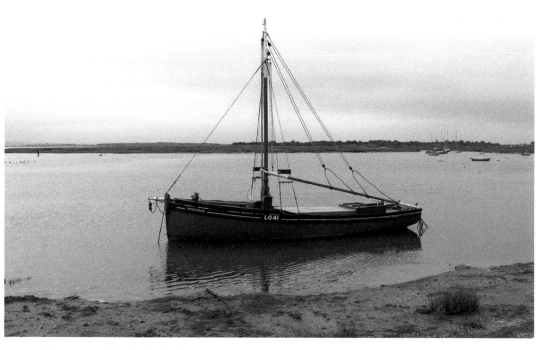

*Endeavour*, a cockle bawley built in 1926 which played a part in the Dunkirk evacuations in 1940.

Nash estimated that over 200 defensive structures were built in the Borough during the war, making the town the most heavily defended part of wartime Essex.

Two concrete anti-tank blocks survive on the seafront, across the road from the eastern end of what is now the Gasworks Car Park, then the site of Southend Gasworks. According to a plaque on the blocks, which it is believed was erected in the 1960s, there were originally 1,804 of them. The complete line of blocks appears to have stretched 3.25 miles from Chalkwell to Thorpe Bay, with additional anti-tank measures such as scaffolding and conical concrete 'pimples' erected to the east of the latter. The Garrison at Shoebury, with its troops and weapons, and the cliffs at Leigh, which formed a natural barrier, were believed to make such blocks unnecessary in those locations. Despite being 7 feet high and weighing several tons, they are easy to miss, as they have been incorporated into the modern sea defences. Nash describes them as offering 'Southend's first line of defence against a seaborne invasion'.

The gasworks were a potential target during the war and had their own defensive pillbox built into the entrance gateway. The western half of the gateway has been removed, but the eastern one, with the pillbox still inside it, remains in situ. This was likely an observation post for the Southend Home Guard and is unique in the Borough.

In Thorpe Bay, three consecutive seafront streets provide surprising evidence of lost road barriers from the Second World War.

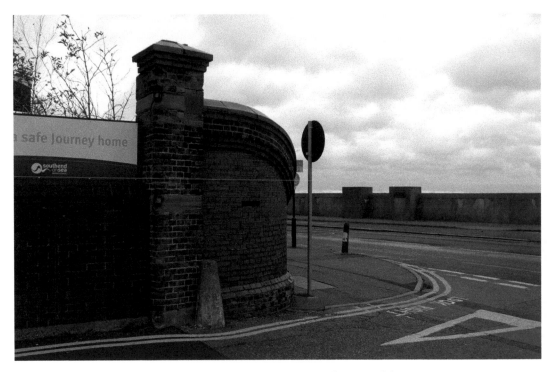

The red-brick gateway (left) at the entrance to the old gasworks site and the two surviving concrete anti-tank blocks (background) which now form part of the sea wall.

In Walton Road, towards the southern end, there are five rows of circular marks in the road surface, laid out in a staggered pattern and measuring 27 feet in extent. These are backfilled holes for anti-tank 'pimples' – conical concrete blocks, each about 2.5 feet high, which were laid out across the road as part of the seafront defences.

Similar circular marks can be seen in neighbouring Clieveden Road, which has a second set of three-row marks further back from the seafront, outside house number nine. Nash found that many of the wartime barriers blocking the roads leading north from the seafront used the first available houses as 'anchor points'. He concluded that it was probable that these marks 'are the remains of an early three-row pimple barrier before the defences were realigned to cross the road 50 yards further S'.

In neighbouring Warwick Road, a change in the tarmac surface outside numbers four and five – which also measures 27 feet in extent – provides evidence of the remains of a road barrier; this part of the road was resurfaced after the barrier was removed.

There were over seventy road barriers in Southend. Some were 'permanent' concrete blocks, others were made of removable steel rails which were inserted into sockets either side of the road. All were removed after the war. It is incredible that the evidence of them survives in these three roads. Their survival is probably due to the residential nature of the streets and their accompanying light traffic usage, which has not necessitated regular resurfacing.

Various wartime structures survive at Shoebury Garrison and form part of the modern recreational landscape of Gunners Park. These include two coastal artillery searchlight

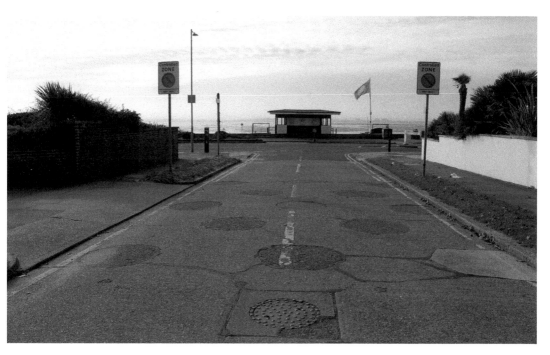

The southern end of Walton Road, showing the circular holes made by five rows of conical anti-tank 'pimples', which were removed and backfilled after the war.

The marks made by three rows of anti-tank pimples in Clieveden Road; there is a second set of five rows nearer to the shelter in the distance.

The southern end of Warwick Road, showing the change in surface tarmac where the wartime road barrier once stood.

emplacements and a pillbox, all standing close together on the seawall. There is also the outline of a demolished Battery Observation Post, which was built onto the northern end of the surviving Heavy Quick Firing Battery of 1899, and some minefield craters, now hidden by undergrowth, just east of the Coastguard Station, near the sea wall.

Two military air-raid shelters also survive at Gunners Park, out of an estimated fifty originally. Both on the west side of Mess Road (one in a private garden), they take the form of grass-covered mounds, each around 40 feet in length and 20 feet in width at the base. There is also what was probably a civilian air-raid shelter close to the publicly accessible military one.

At least thirty concrete pillboxes were erected within the Borough to protect the town and to provide an initial defensive line for the country. Some of these survive at Two Tree Island, Fossetts Way, Nestuda Way and Warners Bridge.

The Two Tree Island pillbox, which can just be made out from the Leigh shoreline where *Endeavour* is moored, stands on the eastern tip of the island but is in very poor condition. The site commands a good view of the estuary towards Southend.

The Fossetts Way pillbox, which stands on the northern boundary of the Borough, looks to have been part of a series of structures running north from the site which were designed to deter and deal with enemy glider landings on the low, flat ground to the east of Sutton and Ashingdon Roads.

The Nestuda Way pillbox, located in a field to the west of that road, lies under the flight path of Southend Airport and stands close to the A127. Both were strategic targets for invasion. The field in which it stands is scheduled for development, so it may not survive

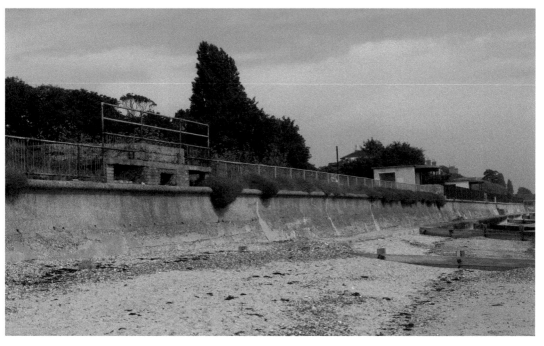

The Second World War pillbox (left) and coastal artillery searchlight emplacements (right) at Gunners Park.

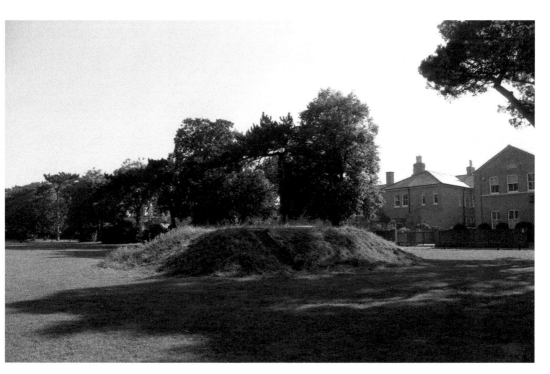

A surviving military air-raid shelter in Mess Road, Shoebury.

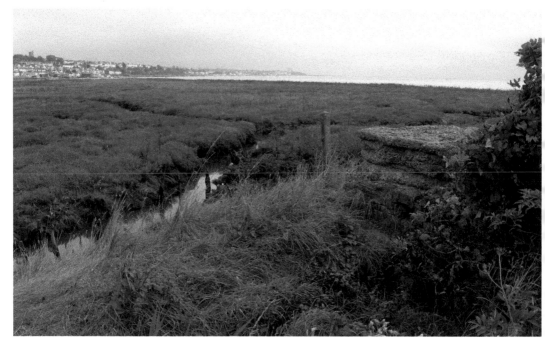

The badly damaged remains of the pillbox on Two Tree Island, showing the exposed layers of concrete and brickwork which were used in its construction.

The Fossetts Way pillbox (right, covered in undergrowth), showing its proximity to the roundabout north of B&Q.

much longer. It, too, was likely built to guard against paratrooper landings. It was one of several pillboxes built to guard the airport. Others survive to the north of the airport in neighbouring Rochford District.

The Warners Bridge pillbox is strategically located for Southend Airport, the Southend-London railway line and road bridge access out of the town into Rochford. It is largely hidden from view in the bushes on the eastern side of the Airport Retail Park. The entrance is on its north-east face, suggesting that it was sited primarily to fire down Rochford Road to the south-west, across where the Harp House Roundabout is now.

A final pillbox survives in the hedgerow at the junction of three fields on private farmland north of Bournes Green Chase (map reference TQ92048661). There may also be one on the south side of Southend Road approximately 100 yards east of Silchester Corner (TQ91628739). If there is, it is buried in undergrowth. Discussions online suggest that it has been demolished, but it has not been possible definitively to prove this.

There is also a pillbox-style 'blockhouse' at the eastern tip of Southend Pier, between the top two decks on the Prince George extension. It is inaccessible to the public but can be seen from the shore. It is painted white and is used as a storage room for the Royal National Lifeboat Institution and Southend Borough Council.

Additional sea-based defences were provided off the Essex coast in 1942–43. These were 'Maunsell' forts, which were built to head off threats of invasion before they reached the county's river estuaries. They were named after their designer, Guy Maunsell, and were equipped with searchlights and guns. Two of the forts, at Shivering Sands and Red Sands, are visible from Shoebury East Beach and from some tower blocks in the town.

Also out in the estuary, there were two high-profile casualties during the D-Day preparations in 1944. One was an American ship called *Richard Montgomery* which

The Nestuda Way pillbox (left), showing its strategic position under the flight path at the south-western end of the Southend Airport runway (background right).

58

The Warners Bridge pillbox, hiding in plain sight behind fencing near the Harp House roundabout.

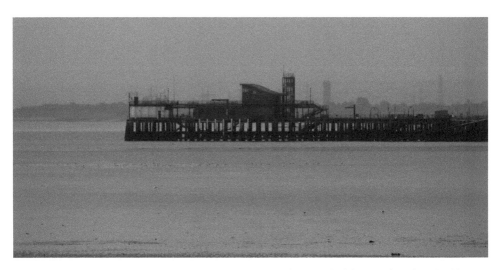

The pierhead of Southend Pier, showing the Second World War blockhouse (the white building at left, between the decks).

sank on the Kent side of the river and cannot be easily seen from Southend. The other, which is much closer to Southend, was a component for a Mulberry Harbour, known as a Phoenix caisson. This was one of several floating concrete-and-steel components which were to be towed across the channel and brought together to provide a

makeshift harbour on the Normandy beaches. The caisson, which is visible from the seafront at Thorpe Bay, is around 60 metres in length and over a mile from the shore. Nash has described it as 'a rare and important example of an historic wartime construction'.

According to an eyewitness, Ian Gordon, a Royal Navy signalman who was on the caisson when it was being towed from Immingham to Southsea, it sprung a leak and was deliberately brought into the Thames Estuary and allowed to sink there.

## DID YOU KNOW?

Three other caisson components exist in English waters – one at Portsmouth and two at Portland. The latter two are virtually complete. Around thirty survive at Arromanches in Normandy, where a complete harbour was constructed as planned.

Some remains of anti-tank ditches survive on Ministry of Defence land at North Shoebury, while the hexagonal footprint of a lost pillbox can be made out on the greensward at East Beach between the shoreline and the southern car park. Wartime trenches have been found at St Mary's Prittlewell Church of England Primary School in Boston Avenue and at Southend High School for Boys. It is highly likely that some underground bunkers and many Anderson shelters also survive. There are several of the latter behind Fairleigh Court in Fairleigh Drive, Leigh, for example. There are also war memorials on Clifftown Parade in Southend, in Sutton Road Cemetery and elsewhere across the town.

The broken Phoenix caisson off Thorpe Bay which was built as a component for a Mulberry Harbour.

# 5. 1960s and 1970s Redevelopment

The 1960s and 1970s saw major redevelopment in central Southend. A partial Ring Road was constructed, the High Street was pedestrianised for much of its length and a new shopping centre was built at Victoria Circus. Chichester Road – known at the planning stage as 'the parallel High Street' – was also built to facilitate the pedestrianisation of the High Street, which had become increasingly busy with traffic, and to allow service access to shops on the eastern side. Homes and businesses were compulsorily purchased, Victorian streets and buildings were swept away, and the town centre was transformed.

The Ring Road was a major undertaking. It was first proposed in 1955 and it was recognised at the time that 'the completion of a proposal of such magnitude could not obviously be envisaged for very many years'. It would require the demolition of hundreds of houses and several business premises, plus civil engineering on a scale hitherto unseen in the town, not to mention all the accompanying traffic chaos. The 1962 electrification of

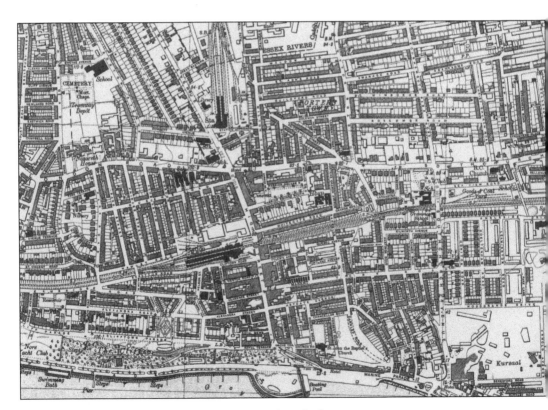

A map of central Southend before the Ring Road was built.

the Fenchurch Street railway line provided some impetus for reconstruction, as most of the bridges on the line needed raising and two of them were on the proposed Ring Road route.

In the end, only the northern and eastern sections of the Ring Road were built. The impact these had on the existing street layout is described below, as are some surviving pre-Ring Road features.

Construction began on the northern section first, in the late 1960s, and was carried out using the proven principles of interwar boulevard design, featuring a dual-carriageway road with a central, tree-lined reservation. It started in the London Road to the west of the town centre, near to the old tramway depot, where a new roundabout was constructed at the northern end of Princes Street. The existing route north-east from there to Victoria Avenue went via Boston Avenue and a 90-degree turn into Dowsett Avenue. The Ring Road was built to cut across this angle and replace Dowsett Avenue for most of its course. Boston Avenue was split into two and the remaining section of Dowsett Avenue was originally kept as a feeder road but, since the millennium, has been converted into a wide footpath. Surviving tree lines on both roads show their original courses. The Ring Road was given an extra-wide central reservation here which could be easily narrowed later to provide additional lanes for vehicles if required.

Boston Avenue, looking south, with the two parallel lines of trees showing the original route of the road.

The parallel treelines of the lost Dowsett Avenue, looking east from Boston Avenue and showing the Ring Road cutting into it from the right.

A new roundabout was also constructed where the Ring Road met Victoria Avenue. This effectively moved the town's 'Victoria Circus' focal point from outside WHSmith's, where Victoria Avenue, London Road, High Street and Southchurch Road met, to the new roundabout on the Ring Road at Victoria Avenue. An underpass called 'Deeping' was constructed south from the roundabout, turning east underground beneath what is now the Victoria Shopping Centre (originally called 'The Hammerson Development' and opened in 1973) to join up with Southchurch Road and Chichester Road to the east of the High Street. The underpass was closed to the public in 2010–11 when the Victoria Circus roundabout was converted into a T-junction. Part of it survives, however, as a service road for the shopping centre.

The construction of the Ring Road and the shopping centre led to the demolition of streets called Broadway Market and Bradley Street (the latter is unnamed on the accompanying map) and the removal of Station Approach, plus the demolition of a complex of shops and covered alleyways known as the Talza and Victoria Arcades. It also led to the bypassing of the historic London Road from Princes Street to the High Street.

From Victoria Avenue, the Ring Road continued eastwards to join up with Southchurch Road just west of Porters Grange, the mayor's parlour, at which point a new roundabout and underpass were constructed. On this side, Milton Street, which led north from Southchurch Road, was cut in two and its southern section was renamed to become part

of Chichester Road. The northern section survived as Milton Street for its remaining length until part of that was later renamed and realigned as Short Street.

The bulk of the existing Ring Road route in this area followed the path of Bradley Street/Station Approach and Prittlewell Street, a residential road running north-west to south-east to All Saints Church from the heart of an 1870s housing estate called 'Porter's Town' (named after Porters Grange). As with Dowsett Avenue, the Ring Road replaced Prittlewell Street for most of its length. Only a very short section at the north-western end remains.

The southern half of Porter's Town, one of Southend's earliest housing estates, was dramatically affected by the construction of the Ring Road. Sutton Street was removed completely. Essex Street was significantly shortened. North Street and Lambert Street were demolished and the area they occupied was redeveloped with high-rise tower blocks called Pennine, Chiltern and Malvern. A fourth tower block, Quantock, was erected between the renamed Milton Street (Chichester Road) and the lost Sutton Street. A short section of the latter survives at its junction with Prittlewell Street and Coleman Street and is used as a turning area for vehicles (it can be seen in the foreground of the Prittlewell Street picture). Another section has been incorporated into a small park area to the south of the Ring Road and east of the Quantock flats: some trees from its lost eastern pavement remain. A third surviving section, now taking the form of a very wide pavement, can be seen outside the Cow & Telescope pub, formerly the Sutton Arms. The Essex Street Car Park has been built in this area, though the section of Essex Street which runs alongside the car park is a modern one and was not there when the Ring Road was put in.

The surviving, very short, section of Prittlewell Street.

Looking north along the route of the lost Sutton Street, whose surviving eastern treeline can be seen connecting the park in the foreground with the surviving section of Prittlewell Street, where the cars are, in the distance.

The short, surviving section of the original Essex Street, looking north, with the railings of the Ring Road which bisected it in the background.

All the above work east of Victoria Avenue led to the bypassing of the historic Southchurch Road on its north side between the High Street and Porters Grange. From the latter, the eastern section of the Ring Road, which was built in the mid-1970s, ran due south along the course of four contiguous residential streets: Porters Grange Avenue, Bankside, Corsham Road, and Darnley Road. These ran in an almost complete straight line, with only small chicanes between them, so were comparatively easy to convert into a dual carriageway, although again the work required the purchase and demolition of many houses.

Porters Grange Avenue ran south from Southchurch Road to the junction of Whitegate Road and Grange Gardens. Much of this has been taken up with the southern section of the underpass and its slip roads.

Bankside was arguably the most challenging stretch of the route, as, although it was only a short section, it was one of the two sections over which a railway bridge ran. The latter needed widening, something which was carried out as part of the electrification work. This was done in the 1960s, before the rest of the eastern section of the Ring Road was started.

Bankside ended at Quebec Avenue, where Corsham Road took over. Quebec Avenue ran perpendicularly across these two streets and was consequently split into two by the Ring Road.

Corsham Road ended at York Road, another east-west thoroughfare which was cut in two.

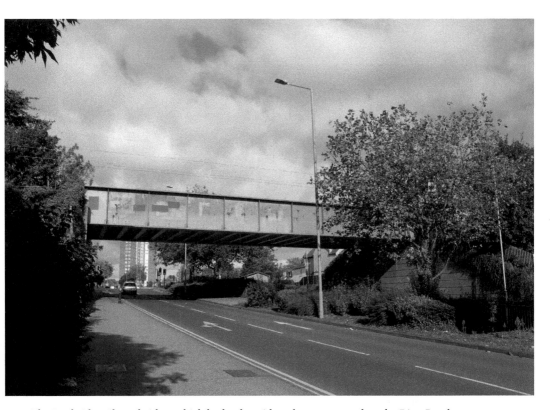

The Bankside railway bridge, which had to be widened to accommodate the Ring Road.

Quebec Avenue, looking west and showing how the Ring Road cut it in two.

York Road, looking west and showing both the Ring Road cutting through it right-to-left and the ends of houses which have been exposed because others which stood in front of them have been demolished.

Darnley Road ran south from York Road, passing Heygate Avenue and Hartington Road on its way to a junction with Chancellor Road. It was here that the Ring Road was to turn west and a large roundabout was constructed in preparation. This roundabout was planned to send a spur road east to Woodgrange Drive and Southchurch Avenue, whilst the main Ring Road would continue west, probably via Chancellor Road and Alexandra Street, and then turn north somewhere around Park Street to complete the loop at the London Road/Princes Street roundabout. The spur road was built, but not the rest of the Ring Road. Some houses in Chancellor Road were demolished to accommodate the roundabout. A considerable section of Hartington Road was removed, along with all of Myrtle Road, which was a cul-de-sac off of it.

The construction of the spur road shortened both Hartington Road and Pleasant Road. It also cut through the historic Old Southend Road, whose surviving southern section was largely incorporated into the road layout of another new roundabout at the junction of Southchurch Avenue. The whole length of the Ring Road that was built (the northern, eastern and spur sections) was renamed 'Queensway' in 1977 to mark Queen Elizabeth II's Silver Jubilee.

Prior to the construction of the Ring Road, the route to the seafront had continued south via a curving southern section of Darnley Road which was later renamed 'Seaway'.

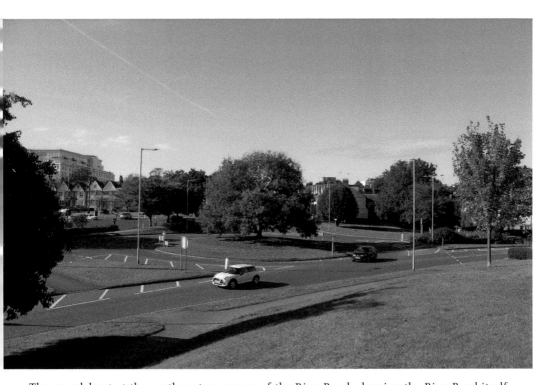

The roundabout at the south-eastern corner of the Ring Road, showing the Ring Road itself (Queensway) on the right, the spur road to Woodgrange Drive on the left and, in the background (centre), some houses in Chancellor Road, which was planned to be replaced by the southern section of the Ring Road which was never built.

Looking south across the spur road to Hartington Road, whose northern section here was removed during the spur road's construction, as was the whole of Myrtle Road, which extended away from the photographer through the area of tree-lined greenery on the right-hand side.

Looking north from the Southchurch Avenue roundabout along the original line of Old Southend Road, whose surviving section can be seen in the distance.

This had parking on either side and joined up with the southern end of Hartington Road. Following the construction of the roundabout, this thoroughfare was closed and incorporated into the existing parking area. While Seaway no longer exists as a street, its name survives in the name of the car park there and the route of it can still be traced between the parking spaces.

The southern and western sections of the Ring Road, which were envisaged to run through Clifftown, were too difficult and expensive to deliver. The second railway bridge, near the southern end of Park Street, was, however, reconstructed in 1959 during railway electrification. It feels somewhat out of place now, an unnecessary dual-carriageway bridge in the middle of a quiet residential area.

The 'parallel High Street' of Chichester Road had been planned to connect the northern and southern sections of the Ring Road, but as the latter was never built it was terminated at its southern end at Heygate Avenue. Its northernmost section, as mentioned above, took the form of a renamed portion of Milton Street, between the Ring Road and Southchurch Road. Its next section, from Southchurch Road to Warrior Square South, also followed the course of an existing street, Warrior Square West, which was also renamed.

The next section, to Whitegate Road, was a new construction. Until the mid-1970s Chichester Road terminated here, in part because only the northern section of the High Street had been pedestrianised and Whitegate Road was still being used as a feeder on its west side to take traffic out of the southern half of the High Street and in part because

A section of Seaway Car Park, showing the route of a lost street called Seaway, after which it was named.

The dual-carriageway railway bridge near the southern end of Park Street, looking south from Hamlet Road to Scratton Road.

The junction of Whitegate Road (running right-to-left across the picture) and Chichester Road (which disappears into the distance under the railway bridge).

the railway line prevented further southwards extension, as there was no railway bridge in this vicinity. In due course, however, the railway bridge was constructed and a new extension to Chichester Road, with a lowered roadbed to allow buses and lorries to pass under the railway, was put through to Tylers Avenue. This section was also the only part of the route that was dualled, as any later road-widening here was envisaged to be expensive because of the bridge.

From here, Chichester Road followed the route of two more existing streets, Grover Street, which ran between Tylers Avenue and York Road, and Grove Road, which ran south from there and beyond Heygate Avenue. Both were renamed over the route of Chichester Road, although the section of Grove Road south of Heygate Avenue was retained with that name until the redevelopment of that area with The Royals shopping centre in the late 1980s.

Like the eastern section of the Ring Road, Chichester Road was opened across its full length in the late 1970s.

# 6. Blue Plaques

Southend has played host to many famous people over the years. The iconic, circular blue plaques which mark the houses of the famous are technically a London initiative, but local authorities and community organisations elsewhere operate similar schemes, with variations in plaque design and colour. This section takes a look at some of the plaques in Southend, most of which are green and were sponsored by the Borough Council.

The most famous early visitor to the developing resort town of 'South End' was the Princess of Wales, Caroline of Brunswick (1768–1821), wife of the future King George IV. She stayed at Nos 7–9 Royal Terrace in 1804 and her visit is commemorated by a plaque there. Caroline had an unhappy marriage but was popular with the British people, who thought she had been badly treated by her husband. She is remembered locally in the name of Princess Caroline House in Southend High Street. Caroline's daughter, the five-year-old Princess Charlotte, stayed at Southchurch Lawn in 1801. Additional information about Royal Terrace itself is provided on a second plaque across the road at the eastern end of The Shrubbery public gardens.

Another early visitor to Southend was the young novelist and future Prime Minister Benjamin Disraeli (1804–81), who stayed at Porters Grange in 1833 and 1834. The building was owned at the time by the locally prominent Heygate family, but tenanted by Sir Francis Sykes.

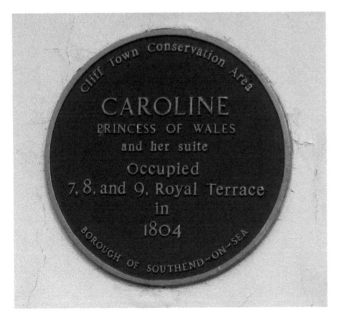

The plaque to Caroline, Princess of Wales, at 7–9 Royal Terrace.

'I can answer for Southend being very pretty,' wrote Disraeli in 1833. 'I am staying at an old grange with gable ends and antique windows, which Mr Alderman Heygate has turned into a comfortable residence, which is about half a mile from the town – a row of houses called a town.'

The following year, much of which he apparently spent hunting, he was just as enthusiastic.

'I live solely on snipe and ride a good deal,' he wrote. 'You could not have a softer climate or sunnier skies than at abused Southend. Here there are myrtles in the open air in profusion.'

Disraeli is said to have written his long poem *The Revolutionary Epick* [*sic*] (1834) while staying at Porters. In the preface to the work, which tackles the topic of the French Revolution and Napoleon, Disraeli writes that he had the idea for it whilst on the plains of Troy, 'surrounded by the tombs of heroes'. His hope for it was to 'evolve a moral, which governors and the governed may alike pursue with profit; and which may teach wisdom both to monarchs and to multitudes'. It is unfortunately a little too verbose for modern tastes.

Another nineteenth-century writer commemorated with a plaque is the local historian Philip Benton (1815–98), aforementioned author of *The History of Rochford Hundred*, who lived in several places in and around the Southend area. Benton was born at North Shoebury House in Poynters Lane. His father, Samuel, was a prosperous local farmer.

Philip followed his father into farming, managing various local estates. He was twice married, firstly to Eliza Squier in 1843 and then to Elizabeth Warren in 1876. He was often

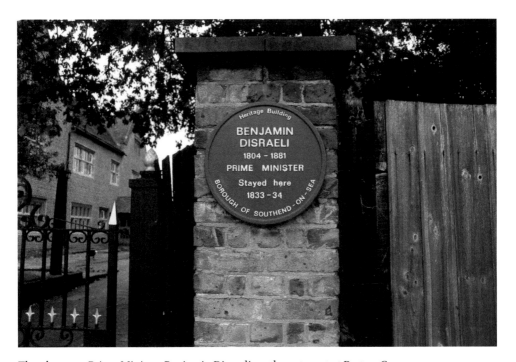

The plaque to Prime Minister Benjamin Disraeli on the gatepost at Porters Grange.

active in local affairs, serving as overseer, surveyor and churchwarden in Shopland and lecturing on English history in Southend.

In around 1885 Philip and Elizabeth moved into his birthplace, North Shoebury House, where he is commemorated with a plaque. They later moved to Frankleigh House in Whitegate Road, Southend. Sadly, paralysis prevented Benton from completing his *History*, but he remained active in local affairs, visiting archaeological sites in the district until he was eighty. In 1892 he donated many artefacts he had collected to the British Museum, with others subsequently going to Southend Borough Council.

Benton died in 1898 at the age of eighty-two and was buried in Shopland churchyard. In the late 1970s and early 1980s, however, the Rochford Hundred Historical Society completed his *History*, based on notes made by the author.

A plaque to a man who made an impression on the national stage is Revd Benjamin Waugh (1839–1908) at 4 Runwell Terrace in Clifftown. Waugh, a congregationalist minister who was born in Yorkshire, was a social reformer who founded the National Society for the Prevention of Cruelty to Children. He also wrote a book about the criminal justice system as it affected children, as well as several hymns. He spent his last years at Runwell Terrace and is buried in Sutton Road Cemetery.

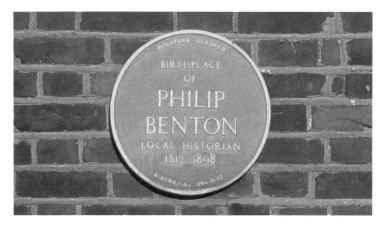

The plaque to local historian Philip Benton on the wall of North Shoebury House in Poynters Lane.

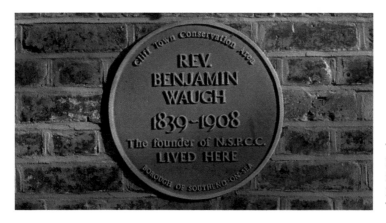

The plaque to Benjamin Waugh, founder of the NSPCC, at 4 Runwell Terrace.

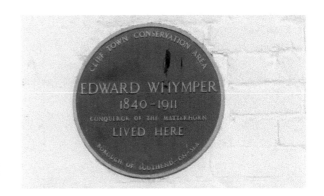

The plaque to mountaineer Edward Whymper at 4 Clifftown Parade.

Another Victorian national hero is the now largely forgotten mountaineer Edward Whymper (1840–1911), who was the first known climber to ascend the legendary Matterhorn. According to John W. Burrows, in *Southend-on-Sea and District* (1909), Whymper 'constantly stayed' in the town. He is commemorated by a plaque on 4 Clifftown Parade, opposite the statue of Queen Victoria.

The nationally important Scottish poet, novelist and dramatist Robert Buchanan (1841–1901), had what Burrows describes as 'a close and intimate acquaintance with Southend', having first visited the town in the early 1880s. It is believed that he came at the request of his wife, Mary, who was dying from cancer, and that they stayed in a house on Clifftown Parade. Mary died soon afterwards and is buried in the churchyard of St John the Baptist. Harriet Jay, Buchanan's sister-in-law and the author of the first biography about him, wrote later that Southend 'had by association become very dear to him'.

Buchanan left Southend to travel but continued to make intermittent visits to the town. In the mid-1880s he returned to settle more permanently, renting Hamlet Court, a house in Hamlet Court Road which has since been demolished. His epic poem *The City of Dream* (1888, often incorrectly rendered as *Dreams*) was probably written there. He lived subsequently at Byculla House on Clifftown Parade, where he is commemorated by a plaque.

Buchanan died in Streatham in 1901 but was buried at Southend, alongside his wife and mother. Harriet Jay died in 1932 and was also buried at St John's. All four of them are commemorated on a memorial there.

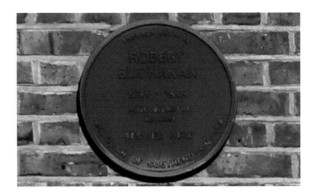

The plaque to the poet Robert Buchanan at Byculla House in Clifftown Parade.

The theatre architect Frank Matcham (1854–1920) is commemorated by a plaque at his former home, 28 Westcliff Parade. Matcham was prolific, producing designs for over 100 theatres, including the Hippodrome, Hackney Empire, Coliseum, Palladium and Victoria Palace theatres in London. He also designed the Tower Ballroom in Blackpool, the County Arcade in Leeds and numerous pubs, hotels and cinemas across the country. Originally from Devon, he spent much of his professional life in London and retired to Westcliff Parade just before the First World War.

A famous figure in Southend from *c.* 1910–60 was Revd George Wood (1888–1974), known as 'Happy Harry'. Wood was an evangelist preacher who regularly set up on Southend seafront to preach religion and politics to townsfolk and holidaymakers. He endured heckling, ridicule and physical abuse in his efforts to spread the word and became something of a cultural icon. He is commemorated by a rectangular plaque on the seawall on Marine Parade, opposite the 'Las Vegas' amusements.

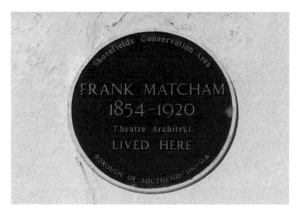

*Left*: The plaque to theatre designer Frank Matcham at 28 Westcliff Parade.

*Below*: The plaque to Revd George Wood, alias 'Happy Harry', on the seafront at Southend, with the pier in the background.

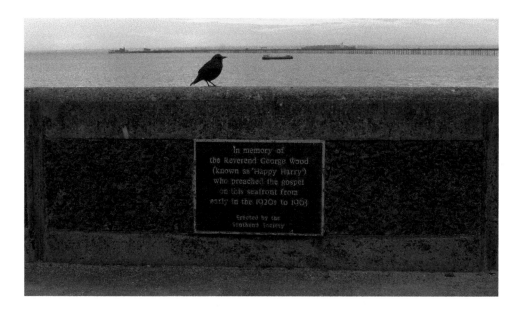

In August 1952 the comedy duo of Stan Laurel (1890–1965) and Oliver Hardy (1892–1957) performed for a week at the Odeon in Southend. The duo's routine – about being stuck on a railway station having missed the last train – was called 'A Spot of Trouble'. A fan club, Saps at Sea, keeps the memory of the pair alive locally. A blue plaque to them can be seen in the reception area of the Park Inn Palace Hotel where they stayed.

A blue plaque adorns the house of David Jack (1898–1958) at 254 Hamlet Court Road in Westcliff. Jack found fame as the first footballer to score a goal at Wembley Stadium, a feat he achieved in the 1923 FA Cup Final. He was also the first player to be transferred for more than £10,000. An inside forward, he played successively for Plymouth Argyle, Bolton Wanderers and Arsenal between 1919 and 1934, scoring 267 league goals in 521 appearances. He also played nine times for England, scoring three goals. He won three First Division titles and three FA Cup winners' medals.

After retiring from the game, Jack managed Southend United, Middlesbrough and the Irish team Shelbourne.

Jack's team, Southend United, is also commemorated by a blue plaque. This is on the outside of the Blue Boar public house in Prittlewell, where the team was founded in 1906. Currently languishing in the National League, Southend reached the dizzy heights of the top of the old Second Division on New Year's Day in 1992 before finishing 12th that season.

*Right*: The plaque inside the Park Inn Palace Hotel which commemorates the comedy duo Laurel and Hardy.

*Below*: The plaque at 254 Hamlet Court Road to the footballer David Jack.

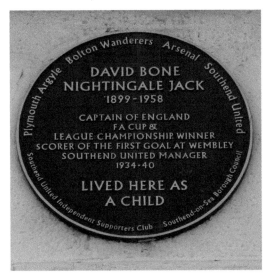

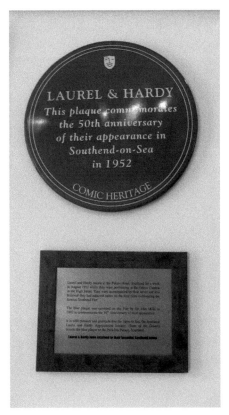

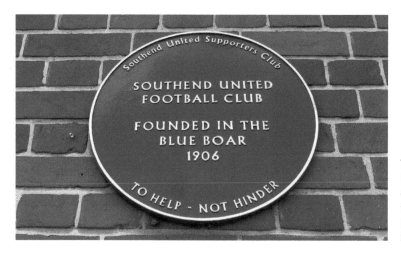

The plaque on the Blue Boar which commemorates the founding of Southend United in the pub.

In the Second World War, twenty-two-year-old Sergeant Ian Clenshaw (1918–40) of 171 Shaftesbury Avenue in Southchurch became the first RAF pilot to die in the Battle of Britain. Clenshaw, of 253 Squadron, was tragically killed on 10 July 1940 when a freak storm brought down his Hurricane aircraft during a dawn patrol off the Humber Estuary near Grimsby. He had joined the RAF Volunteer Reserves in February 1939 and was serving at nearby Kirton-in-Lindsey in Lincolnshire when he crashed. He is buried in Essex, at St Mary the Virgin Church in Kelvedon.

John Fowles (1926–2005), author of *The French Lieutenant's Woman*, was born at 63 Fillebrook Avenue in what is now regarded as Leigh-on-Sea (although the land here was historically in Prittlewell parish). He also attended the Alleyn Court Preparatory School before going to Bedford School in 1939. There, he excelled at sport and became head boy. After a brief spell of military service, he went to New College, Oxford. He studied languages and became a teacher, including in Greece.

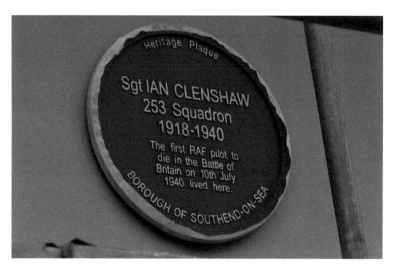

The plaque to Sergeant Ian Clenshaw at 171 Shaftesbury Avenue.

Fowles' first published novel, *The Collector* (1963), explored the relationship between a man from one social class who 'collects' and dissects his supposed lover, who hails from a different social class. Major recognition came with his novel *The Magus* (1965), which was based on his experiences of teaching in Greece. *The French Lieutenant's Woman* (1969) is his best-known novel, thanks largely to the 1980s film of that name starring Meryl Streep and Jeremy Irons. His later novels were somewhat experimental. He also wrote short stories and poems.

Fowles never returned to Southend, settling in Lyme Regis from 1968 until his death in 2005.

There is also a blue plaque on the wall of Leigh Heritage Centre in Leigh Old Town which shows the height that the floodwaters reached during the Great Tide of January/February 1953. There was a similar commemorative mark on the Crooked House in Adventure Island in Southend until 2018 when the house was refurbished.

At the time of writing, plans are afoot for the erection of a blue plaque on Leigh Community Centre to Sir David Amess MP (1952–2021), who represented the Southend West constituency from 1997 until 2021. Three more blue plaques are also planned as part of the Essex Women's Commemoration Project. These will be for the first black woman to take part in a beauty pageant (Princess Dinubolu in 1908, intended for erection at Southend Victoria Station), the social historian and folklorist Enid Porter (1908–84), and the actress Peggy Mount (1915–2001).

## DID YOU KNOW?

There is a missing plaque to Bombardier Wells and George Carpentier, two early-nineteenth-century boxers, which was on the Shoeburyness Hotel in Shoebury High Street where they trained. It is reported as going missing during a refurbishment around fifteen years ago.

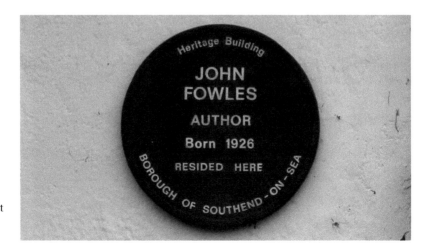

The plaque to novelist John Fowles at 63 Fillebrook Avenue.

Leigh Heritage Centre, showing at bottom-right the circular blue plaque whose white horizontal line marks the level that flooding reached on 31 January 1953.

There should probably be plaques to many others, including: Revd Samuel Purchas (*c.* 1575–1626), travel writer; Revd Arthur Dent (1553–*c.* 1607), religious writer; Sir Herbert Croft (1751–1816), author; Sir William Heygate (1782–1844), Lord Mayor of London; Douglas Jerrold (1803–57), dramatist; Isabella Shawe (1816–1894), Leigh resident and wife of the author William Makepeace Thackeray; Sir Edwin Arnold (1832–1904), poet; Coulson Kernahan (1858–1943), novelist; Warwick Deeping (1877–1950), novelist, after whom the aforementioned Ring Road element, Deeping, was named; Dame Rebecca West (1892–1983), author; Sir Henry 'Chips' Channon (1897–1958), politician; John Betjeman (1906–84), poet; and Frankie Howerd (1917–92), a well-known comedian who served in the army at Shoeburyness. Buchanan, Deeping and the town's first mayor, Thomas Dowsett, are buried in the churchyard of St John the Baptist, along with many of the town's founding fathers.

There are other plaques of different designs around the town. These include a silver plaque on a memorial at Shoebury Garrison which commemorates the loss of several soldiers in an explosion in 1885, a plaque on the gates of Priory Park which acknowledges the gifting of the park to the town in 1917 by local benefactor R. A. Jones, and two plaques on Southend Pier – one rectangular and blue, one red and circular – which commemorate its pivotal role in the Second World War and the importance of its railway, respectively.

# 7. Hidden Heritage

This chapter looks at some miscellaneous items of 'hidden heritage' which are dotted around the Borough, starting with two Iron Age encampments in Prittlewell and Shoebury.

The first of these, at Fossetts Farm, behind Waitrose, may even date from the Late Bronze Age, *c.* fifth–eighth centuries BC. It comprises enclosures of ditches and ramparts which could have had either domestic or military use. Usually known as 'Prittlewell Camp', it is a rather inconspicuous area of trees and undulations, but beneath the undergrowth lie traces of the original enclosure.

The camp appears to take the form of a circular hill fort, measuring 800 feet in diameter. Much of the original enclosure has been ploughed out, but the south-western corner retains a clearly defined ditch and rampart. The height from the bottom of the ditch to the top of the rampart is at least 6 feet in some places. In the south-eastern corner there is a raised mound, around 6 feet high, which appears to date from a later period, possibly as late as medieval. It may have had a windmill on it.

The second Iron Age encampment is the so-called 'Danish Camp' at the old Shoebury Garrison site, close to the Second World War air-raid shelters in Mess Road. Only two sections of its perimeter bank remain. Parts of it were destroyed in the early 1850s when the Garrison firing range was set up, while some has been lost to coastal erosion. The length overall north to south would appear to be around 1,500 feet, though the width is difficult to determine because of the loss of land to the sea. The two surviving stretches of rampart are as much as 6 feet high in places, whilst a now filled ditch around them was found in the nineteenth century to be around 9 feet deep. Evidence of Iron Age roundhouses and trades such as spinning and weaving was found during the late 1990s. The main period of occupation, dated from these activities and some pottery finds, appears to have been *c.* 200–400 BC. There is also evidence of extensive trading with southern central England and beyond. It was long thought incorrectly to have been constructed by Viking invaders, hence the 'Danish' name.

Arguably Southend's most famous early resident is the so-called 'Saxon King', whose grave was found in Prittlewell in 2003. Roman and Saxon burials had been found in 1923 in the same vicinity to the east of Priory Park, between the railway line and Priory Crescent, during the latter's construction, but the 2003 find of an intact, high-status burial chamber was of international significance. It has been described by Sue Hirst and Christopher Scull, authors of *The Anglo-Saxon Princely Burial at Prittlewell, Southend-on-Sea* (2019), as 'the richest and most important Anglo-Saxon burial found since the 1939 discovery of a great ship burial at Sutton Hoo'. It comprised a wood-lined chamber furnished with a great variety of high-quality grave goods and dating from the late sixth century. Academic discussion is ongoing about who the buried individual was, but it seems likely that he was related to the ruling Saxon families.

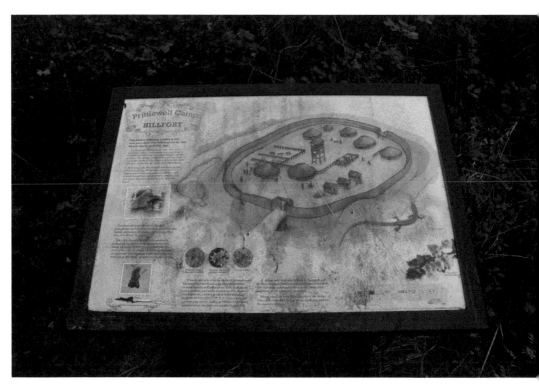

An information board about the Prittlewell Camp hill fort, which lies behind Waitrose, off Eastern Avenue.

The modern mound in Priory Crescent which has been constructed – with an appropriate plaque on top – to mark the site of the burial of the so-called 'Saxon King'.

On to the medieval period, and in Leigh Old Town there is an unusual stone at the entrance to the Leigh-on-Sea Sailing Club at the eastern end of the High Street. This is a 'mark stone', which once marked the physical centre of community activity in Leigh. Here were the original Leigh marketplace and fairground and it was here too that the town crier made his announcements.

The route out of the village up Leigh Hill was originally in this vicinity. It remained the main thoroughfare even after the railway line was constructed in 1856, as a level crossing was provided where the marketplace had been.

The mark stone stood initially against the south-western corner of the King's Head pub, which was demolished in the late 1800s to make way for the old Leigh railway station, which replaced it. The sailing club now occupies the station site.

The predecessor to the Crowstone (see Chapter 1) also survives and is now in Priory Park. There have been at least three such stones in the estuary: the first was erected in the thirteenth century, the one in the park dates from 1755 and the current one is from 1837. Its role was to mark the eastern boundary of jurisdiction of the City of London over the River Thames.

The old Crowstone in Priory Park remained for a time alongside the current one in the river, but it was moved to the park in 1950. It carries now the barely visible city arms and the no longer legible names of several lord mayors.

The mark stone in Leigh High Street, at the base of the pillar outside the Leigh-on-Sea Sailing Club.

A rare infrastructural survivor in Southend's mother community of Prittlewell is the village water pump. This stands at the foot of the hill beneath the village next to Prittle Brook. It dates from the early nineteenth century and can be seen at the junction of what are now Priory Crescent (south) and Victoria Avenue. It was still in use in the early twentieth century.

Another ancient water supply outlet survives in the High Street in Leigh Old Town. This is a well-head, also from the early nineteenth century. Water was carried there via a conduit from a spring on the clifftop above.

The 1755 Crowstone in Priory Park, with Prittlewell Priory in the background.

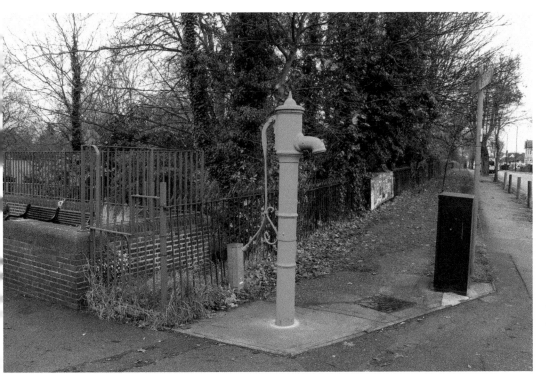

Prittlewell's early nineteenth-century water pump, the original source of water for the village.

The land on which the well-head – now generally known as 'The Conduit' – stands was given by Leigh's Lady of the Manor, Lady Olivia Sparrow (1778–1863). An iron tablet at the location, which is dated 1846, records that it was reinstated by subscription in 1825. The Conduit was used until 1920. A stone also once stood at the spring on the cliffs in what is now Rectory Grove, but it was relocated to The Conduit enclosure in 1981, where it can still be seen.

In 1885 Southend's old wooden pier was given a new brick toll house, featuring an ornate, imposing archway with fish reliefs on either side of the entrance. This survived the demise of the wooden pier and its replacement by the current iron one in 1889. By 1931, however, the toll house too was replaced. The fish reliefs were transferred to the walled garden in Priory Park, where they can still be seen. They appear in many old photos of the pier.

The foundation stone of Southend's long-demolished Victoria Hospital has also been saved and is on display outside the modern Southend University Hospital. It can be seen in front of that building, close to the bus stops in Prittlewell Chase. The Victoria Hospital was founded in 1887 to mark Queen Victoria's Golden Jubilee and stood in Warrior Square. It was replaced by what is now Southend University Hospital in 1932.

Similar evidence survives of a predecessor of the current Gypsy Bridge in Leigh, which crosses the railway line below the public gardens at the eastern end of Cliff Parade. The bridge takes its name from a boat called *Gypsy* which was home to the Essex

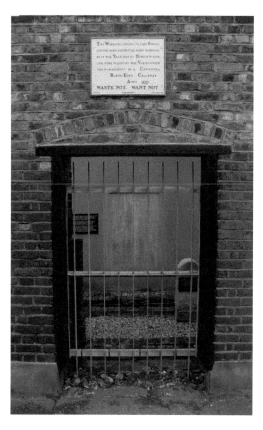

*Left*: The enclosure in Leigh High Street which contains the historic fishing village's water supply well-head, known as The Conduit.

*Below*: Some fish designs from the old Southend Pier toll house which now reside in the walled garden at Priory Park.

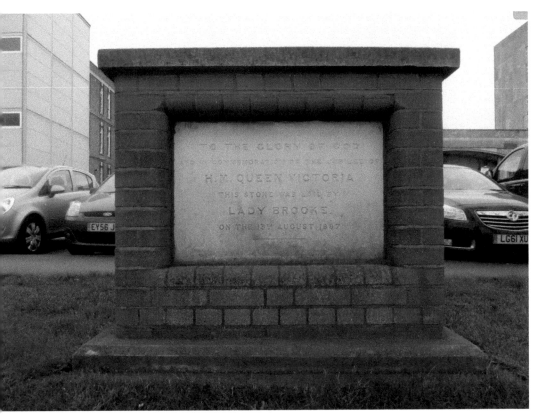

The foundation stone of Southend Victoria Hospital, which originally stood in Warrior Square but is now outside Southend University Hospital in Prittlewell Chase.

Yacht Club. The current bridge was built in the 1960s, but the foundation stone of its predecessor has been retained and is displayed on the greensward next to the bridge's north end. It records the erection of a public footbridge by Leigh Urban District Council in what looks like either May 1897 or 1907. Several photographs of this bridge survive, including in postcards.

It may surprise some to learn that there is a level crossing for pedestrians over the public railway line in Southend. This links Woodgrange Close and Pilgrims Close in Southchurch. It may not be around much longer, however, as Network Rail is looking to close it as part of a wider programme to improve safety on the railways.

There are two vehicular crossings in High Street and Blackgate Road in Shoebury, but these are on the private extension to the public rail network which serves the New Ranges. There are also some publicly inaccessible crossings on the New Ranges.

Old advertising slogans on the sides of buildings are another survivor from times past. At 612–14 London Road, Westcliff, next to the garage, there is signage for the Rendezvous Tea Gardens and Lending Library, and Wills' cigarettes. At 323–5 Eastwood Road North in Belfairs there is a faded advertisement for a newsagent, stationers, and confectioners. Other examples exist across the town.

The Gypsy Bridge at Leigh, showing, in the foreground, some surviving foundations from the current bridge's predecessor, and, in the background next to the tree stump, the rectangular foundation stone of that previous bridge.

The pedestrian level crossing in Southchurch which links Woodgrange Close with Pilgrims Close.

Old advertising for the Rendezvous Tea Gardens and Lending Library on the wall of 612–4 London Road in Westcliff.

Various other types of old signage survive. These include direction signs, such as those in Bellhouse Road (opposite Leighfields Road) for Oakwood Park, and in Southchurch Boulevard (at Wick Chase) for Bournes Green Park. One of the best surviving signs, however, is on the Southend Association of Voluntary Services (SAVS) building at 29–31 Alexandra Street, which sports the legend 'County Borough of Southend-on-Sea'. The local authority had County Borough status from 1914 to 1974 and this 1889 building was one of many in the vicinity of Alexandra Street which was adapted to serve the growing populace until they were all vacated in the 1960s for purpose-built premises in Victoria Avenue.

Several examples of red telephone boxes also survive around the Borough, including in Clifton Terrace and Leigh High Street. The one to visit, however, is at the junction of Alexandra Road and Capel Terrace in Southend. This has recently been transformed into the Clifftown Telephone Museum and is one of the smallest museums in the country. It explores the Victorian history of the area through an information board and some sound recordings which are introduced by the actress Dame Helen Mirren, who grew up in the town.

These iconic cast-iron telephone boxes, with square kiosks and domed roofs, were designed for the General Post Office by Sir George Gilbert Scott to mark King George V's Silver Jubilee in 1935. They are known as the 'K6' type and around 70,000 of them were installed across the country.

The Southend Association of Voluntary Services (SAVS) building at 29–31 Alexandra Street, which sports the legend 'County Borough of Southend-on-Sea'.

The Clifftown Telephone Museum, at the junction of Alexandra Road and Capel Terrace, which is one of the world's smallest museums.

The Essex Yacht Club's current headquarters, HMS *Wilton*, is also of interest, as it was the first warship in the world to be made of fibreglass. It was a minesweeper, and this material was chosen as it had a low magnetic signature, thus reducing the threat posed by magnetic mines. It was known colloquially as 'HMS *Tupperware*'. The ship saw active service from the mid-1970s to the mid-1990s and has been the yacht club's home since 2001.

Another little-known fact is that there are two 'Danish houses' in Shoebury which were built by and for the partners of the then Southend-based firm Dansk Design in the early 1980s. Dansk Design imported and sold Danish furniture and the houses were made by Hosby in Denmark and shipped to the UK in kit form. They were then erected on land in Ness Road. They included triple-glazing, heat exchangers and saunas and were very advanced and high-spec for their time.

There is still a Dansk Design showroom in Rayleigh. The houses are believed to be unique in the area.

Finally, a look at statues. Most people will be aware of the 1898 statue to Queen Victoria in Clifftown Parade and the statue of a commuter and his partner outside Southend Victoria station, but there are other statues which may not be so well-known. One of these is a bust of Sir Winston Churchill, which stood originally in the eponymous Churchill Gardens, which was opened in 1966 and named for the former prime minister. The bust is now in the Civic Centre.

The world's first fibreglass warship, HMS *Wilton*, viewed from the Gypsy Bridge and currently home to the Essex Yacht Club.

The matching pair of Danish houses in Ness Road, Shoebury, which were built in the early 1980s.

A much more recent statue is that to Eric Kirkham Cole, founder of EKCO (named from his initials), which was erected in 2020 in the appropriately named Cole Avenue, on the redeveloped site of the old EKCO factory between Priory Crescent (north) and Thornford Gardens. Cole founded the company in 1930 and it became a world leader in electronics. He was a pioneer in providing apprenticeships, paid holidays and pensions for his employees, and he was much loved as a result. EKCO employed 8,000 people at its peak and was the biggest employer in the town. The suit of the statue of 'Our Eric' features 182 photographs of the EKCO factory, while the figure stands on a model of one of the company's famous radios.

This chapter has taken a whistle-stop tour around some items of the town's hidden heritage, but I hope that it and the previous chapters have given you an insight into some aspects of secret Southend and a thirst for finding out more about them.

The statue of E. K. Cole which stands in Cole Avenue on the site of the former EKCO factory.

# Acknowledgements

The author would like to thank the following: staff at Thorpe Hall Golf Club and the Park Inn Palace Hotel for giving permission to photograph Thorpe Hall and the Laurel & Hardy plaque, respectively; Nicki Uden/QinetiQ Defence & Security Contractors for information about boundary markers within the New Ranges; Andy Steele for advice on getting to the Mulberry Harbour safely; Brian/Southend-on-Sea Lifeboat Station for information about the pierhead blockhouse; Abbie Greenwood/Southend Borough Council, Graham Watts/ Essex Women's Commemoration Project, Dee Gordon, Simon Wallace, Keith Baxter and members of the South Essex Historical Plaques Facebook group for information on blue plaques; the homeowner of the house with the Sergeant Ian Clenshaw plaque on it, who allowed me to photograph it close-up and gave me some background information; and Dee Gordon and Bob Brent for information about the Danish houses. I would also like to thank my wife, Alison, who accompanied me on research trips and helped shape my thinking.

The author and publisher would like to thank the following for permission to use copyright material: the photograph of Suttons – Judith Williams; the parish map – Dr Jayne Carroll from the English Place-Name Society/University of Nottingham. The Google map has been reproduced under that organisation's fair use and attribution terms (June 2021). The Southend town centre map has been reproduced under a Creative Commons Attribution-NonCommercial-ShareAlike 4.0 International (CC-BY-NC-SA) licence with the permission of the National Library of Scotland. Chapman & André's map and the Second Edition Ordnance Survey Map are believed to be out of copyright in the versions used and have been supplied and reproduced by courtesy of the Essex Record Office.

Every effort has been made to seek permission for other copyright material used in the book. If we have inadvertently used any without permission/acknowledgement we apologise and will make the necessary correction at the first opportunity.

# Bibliography

## Books

Benton, Philip, *The History of Rochford Hundred* (Rochford: The Unicorn Press, 1991 edition).

Burrows, V. E., *The Tramways of Southend-on-Sea* (Huddersfield: The Advertiser Press Ltd, 1965).

*Description of Bounds [of Southchurch parish]*, Essex Record Office (ERO) D/DMQ E1/14 (c. 1830).

*Envelope containing various papers including copy of 'The boundary of the parish of N. Shoebury in the County of Essex as it appears by a Perambulation and view taken on Monday the 2nd day of April 1838'*, ERO D/DMQ M30/18 (1838).

Glennie, Donald, *Our Town: An Encyclopaedia of Southend-on-Sea & District* (Southend: Civic Publications, 1947–8).

Gordon, Dee, *Southend at War* (Stroud: The History Press, 2010).

Gordon, Dee, *The Secret History of Southend-on-Sea* (Stroud: The History Press, 2014).

Hirst, Sue and Scull, Christopher, *The Anglo-Saxon Princely Burial at Prittlewell, Southend-on-Sea* (London: Museum of London Archaeology, 2019).

Nash, Fred, *Survey of World War Two Defences in the Borough of Southend-on-Sea, Vols. I & II* (Southend: Southend Borough Council, 2001).

*Perambulation [of the boundaries of Prittlewell parish]*, ERO D/P 183/6/7 (1823).

Reaney, Dr P. H., *The Place-Names of Essex* (Cambridge: Cambridge University Press, 1976 (reprint)).

Rippon, Stephen, 'Landscape Change during the "Long Eighth Century" in Southern England' in Higham, Nicholas J. & Ryan, Martin J., *The Landscape Archaeology of Anglo-Saxon England*, pp.39-64 (2010).

Sellers, Leonard, *Eastwood, Essex: A History* (Peterborough: Fastprint Publishing, 2010).

Southchurch Parish Vestry minutes, ERO D/P 120/8/7 (1848–1922, especially 24/10/1902).

*Southend Borough Council Minutes* (Southend: Southend Borough Council, various dates).

Williams, Judith, *Leigh-on-Sea: A History* (Chichester: Phillimore & Co. Ltd, 2001).

Williams, Judith, *Shoeburyness: A History* (Chichester: Phillimore & Co. Ltd, 2006).

Winchester, Angus, *Discovering Parish Boundaries* (Princes Risborough: Shire Publications Ltd, 2000, 2nd Ed.).

Yearsley, Ian, *A History of Southend* (Chichester: Phillimore & Co. Ltd, 2001).

Yearsley, Ian, *Southend in 50 Buildings* (Stroud: Amberley Publishing, 2016).

## Websites

Archaeology Data Service: Defence of Britain Archive – https://archaeologydataservice.ac.uk/archives/view/dob/index.cfm

Battle of Britain London Monument – http://www.bbm.org.uk/airmen/Clenshaw.htm

Beyond the Point – http://beyondthepoint.co.uk/

Butterfield, David, *British Street Names* – https://www.spectator.co.uk/article/british-street-names

*Echo* newspaper, 'Pub wall find reveals name change' (11 June 2008) – https://www.echo-news.co.uk/news/local_news/2334233.pub-wall-find-reveals-name-change/

*Echo* newspaper, 'Southend's iconic Mulberry Harbour is recognised as world-changing' (22 March 2018) – https://www.echo-news.co.uk/news/16106355.southends-iconic-mulberry-harbour-recognised-world-changing/

Heritage Gateway – https://www.heritagegateway.org.uk/Gateway/

National Library of Scotland – https://maps.nls.uk/

Rippon, Stephen, *Stonebridge: An Initial Assessment of its Landscape Character* – http://humanities.exeter.ac.uk/archaeology/research/projects/stonebridge/

South Essex Historical Plaques – www.facebook.com/125400617526514

The Essex Milestone Map – http://pnelson.orpheusweb.co.uk/msess/index.htm

The Sons of the Desert: Saps at Sea – http://saps-at-sea.co.uk/

The Southend Timeline – https://www.southendtimeline.co.uk/